BALKON

BALKON

PHOTOS AND TEXTS BY

ORHAN PAMUK

TRANSLATED FROM THE
TURKISH BY EKIN OKLAP

STEIDL

"Every photograph is not just the image of a frozen moment, but of the past and future too. Because to take photographs is to nurture hope."

Celal Salik, 'Looking at a photo album',
7 June 1971, from the daily *Milliyet*

B A L K O N

Between December 2012 and April 2013, I took 8,500 photographs of the view from the balcony of the apartment where I lived and wrote in the Cihangir neighbourhood of Istanbul. While taking these photographs, I came to realise that there was a link between this new activity I was pursuing with so much vigour and conviction, and my state of mind. But another part of me refused to read too much into it, or to even think about why I was taking all these photographs. Five years on, I write this introduction as a way of exploring my state of mind at the time, and of investigating the broader connection between photography and the photographer's 'mood'.

In November 2012, shortly before returning to Istanbul, I finally did what I had long dreamed about, and went to New York's famous photography shop B&H, on 9ᵗʰ Avenue in Midtown, to purchase a camera and a telephoto lens. I had been taking photographs since I was ten years old; I'd owned many cameras in my life, but never one that was quite as clever and multifunctional as this Canon 5D.

Like a professional photographer, I had also bought a tripod, which I then carried with me on the flight back to Istanbul and gleefully set up on my balcony. I loved running my hands over my new camera, and I couldn't wait to master all its functions. My body, my arms, and especially my fingers were impatient to put this over-talented machine to use and record the landscape before us.

It's true: when I set up that camera with its powerful telephoto lens on my balcony, my foremost thought was to *record*. The desk

I sat on every day to write my novel, and the balcony next to it, commanded a particularly generous view of the city. (It is at that desk that I write these words today, five years later.) I believe there were two fundamental emotions behind my desire to record all the nuances of that view:

1. Sometimes – especially on winter days – the view looked inordinately 'beautiful' to me, and I would 'idealise' what I saw. This beauty was fleeting, and I must make sure to preserve it; indeed it was my duty to do so, I owed it to the world. This idea of beauty and impermanence was epitomised in my mind by the beams of light that would appear intermittently among the city's domes and the fast-moving clouds that gathered in the sky, particularly in January and February. I had to record these ephemeral sights as soon as they materialised over the landscape, and before they dispersed. The very transience of these moments of fortuitous beauty meant that I bore an even greater responsibility to catch them before they passed. I took most of the photographs in this book having sprung up from my desk and rushed to the balcony to capture a scene before it was too late. They are not planned, premeditated images; I didn't adjust my camera's settings or think carefully every time about how to frame each shot. I took these photographs with a sense of mounting urgency, and the constant thought that whatever happened, 'I had better not miss this!' Slowly, the agitation and the burden of responsibility all this produced became conjoined, in my head, with the weight I felt upon my soul around that time of my life.

2. The other emotion that impelled me to take photographs was the belief that from my balcony, *balkon* in Turkish, I could see 'everything'. This balcony of my apartment just behind the Cihangir Mosque looks out on a vast panorama, and enjoys a vibrant view of the Bosphorus, the mouth of the Golden Horn, the Sea of Marmara, and the islands towards the east. All day I can see freight ships, little rowing boats, city line ferries, and fishing boats sailing back and forth in front of me. At various times throughout the course of the years, this endless flow of activity, as well as the cloud formations and the shafts of light above it, have made me feel I must record them all before it is too late.

This urge to record what I saw was as much a product of my enthusiasm, as a writer of Istanbul, to discover and learn everything I could about the city, as of my fixation with 'boat spotting' on the Bosphorus. As I wrote in my memoir *Istanbul*, I sometimes felt, especially as a child, that the number of ships that passed through the Bosphorus and the order in which they came were somehow my responsibility. In my engagement with these photographs, there was something akin to that of a bureaucrat wanting to observe and record everything that goes past his door. But mostly I rushed over to my camera because I felt there was something 'noteworthy' in a freighter nearing the Asian shore of the city, or in the smoke blowing from the chimney of a boat heading for the Princes' Islands, or in a coastguard vessel sidling up to a ship in the middle of the night. What motivated me was either the allure of the landscape itself, or the discovery of new 'information'.

I usually pressed the shutter release button as a response to the beauty in front of me, but in doing so I would also feel that I was capturing some important detail. Conversely, even when I took a picture primarily to record some new discovery, I would convince myself that there was an element of aesthetic appreciation there, too. At the same time, I was only an amateur photographer taking pictures purely for pleasure and with no thought to what I would do with them afterwards, so I had trouble explaining to myself what exactly the purpose of this whole exercise might be.

Another reason for taking photographs was that the sea, the minarets, the ships, the bridges, the rowing boats, the sailboats, and everything else that I could see stretching before me, were saturated with memories. When I was little, back in the 1950s, I used to accompany my mother to visit my aunt in Cihangir. So I already knew even before I came to live here that Cihangir Mosque, built on this rocky promontory back in 1559 by Suleiman the Magnificent in memory of his son Cihangir, who died as a boy, was blessed with the most beautiful view in the city. I suppose I've been looking south-eastwards all my life, from the hills on the western side of the Bosphorus – from Cihangir, but also Gümüşsuyu, Taksim, and Nişantaşı – over towards the other side, to Asia, to Üsküdar, the Maiden's Tower, and Çamlıca Hill. You will find similar views of the Dolmabahçe and Beşiktaş seafront, of Üsküdar and Çamlıca, from any one of the many apartments

in Nişantaşı I visited as a boy. I have been inside countless homes with views of the Maiden's Tower, the Selimiye Barracks, and the Haydarpaşa train station. But what is unique about my balcony in Cihangir is that it also offers views further westward into the city, and of the neighbourhoods north of the Golden Horn in which I grew up. Finally, you can also see from my balcony the same kinds of views enjoyed from foreign embassies in Ottoman times in and around Istiklal Street in Beyoğlu, those now familiar, 'classic' Istanbul views that have historically been the subject of choice for landscape paintings and pencil sketched silhouettes of the city made by Western travellers and artists.

When I first moved into this apartment in 1995, I couldn't get enough of the vast and beautiful view from its balcony, so much so that it would often prevent me from concentrating on my novel. Back then I was only using this apartment as an office, not as a home. By the time I was taking these photos in 2012, fifteen years after I first moved my office there, I had grown immune to the view. Whenever I had visitors, the question they were most likely to ask was 'How can you write with a view like this?' I wasn't lying when I told them in response, 'I've got used to it now!'

While I was taking these photos, I never thought that the attraction of the view might be hindering me from writing my novel. If anything, I knew it was the other way around: I felt the need to look at the view over and over again – or, more accurately, to take photographs of it – because I was finding it so difficult to write. I sensed that the anguish I was feeling must have something to do with the fact that my novel wasn't progressing as I would have wanted it to – which in my experience means a persistent failure to turn into the sort of carefree man who is able to write the novel he wants to write in the way he wants to write it. I tried as hard as I could, I sat at my desk and forced myself to be a different Orhan, a happy Orhan. Until some old, rusty freighter crossing the Bosphorus right under my nose caught my eye, and I put down my pen, left the novel, and hastened to the camera in my balcony, seized by the certainty that there was something beautiful in that scene that I couldn't afford to miss.

When writing, I have always had the habit of lifting my gaze from the nib of my fountain pen and the piece of paper before me to look up at some far-off view. I found out early on in my career as

a writer that observing the sea, the mountains, or an island in the distance, can enhance my creativity and assist me in giving form to my ideas. I felt better, and I wrote better, with a view at my disposal, with distant strips of land and islands and sharp purple peaks for my gaze to explore, and in-between, a stretch of sea, perhaps a bay, and of course the Bosphorus. My most basic responses to these views – the way they made me feel uplifted and perceptive, fuelled my imagination, and insulated me from earthly fears and worries – matched what has been written about the theory or philosophy of Chinese landscape painting. The view from my balcony invited me to seek quietude and introspection, to let go of material concerns in favour of more intellectual pursuits.

But in December 2012, the same view became something that spurred me to action, made me restless, got me to leap off my chair, and sometimes even upset me. The cause of all this was undoubtedly the new camera that perched on the tripod I had set up on the balcony. Thanks to this camera and its telephoto lens, the vista before me had turned into something more than a spiritually enriching background, or a poetic realm I could turn to every now and again for comfort. It was now a fertile, virgin soil full of features I must collect and preserve. It was a joy and a thrill to delve into the minutiae of the panorama I could see from my balcony and make a record of what I found. But I also began to feel a growing sense of responsibility, perhaps even of duty, towards the beauty I was discovering.

These were the emotions I experienced as I began to take photos with my new camera. I enjoyed the sound it made every time I pressed its shutter release button, I found it satisfying to hold it in my hands, and to get up from my desk to go over and fiddle with its settings. I loved peering through the viewfinder to compose the frame, and using the fingertips or sometimes even the palm of my left hand to gently turn the 'zoom' in and out. The more I focused the lens on Russian warships or ramshackle fishing boats or mysterious beams of light upon the horizon, the more invested I became in observing and recording all these details.

The telephoto lens, this new plaything which could bring the faraway up close, had altered my relationship with the view. It was time now to discover what the naked eye couldn't see, the details I couldn't identify from my writing desk, and to explore all the

beauty that my new camera could unearth. Of course the view had already been vivid and beautiful even before I'd set up the camera on my balcony, but it had always been panoramic in scale, the expression of an overall mood.

Now it was these surprising, incidental details I wanted to pin down, instead of the general poetic mood. The new camera had changed the nature of my poetic engagement with the way the world appears, and transformed my interest in the individual elements that form a landscape into an encyclopaedic drive to observe, categorise, and record. My initial approach when I first began taking pictures in December 2012 had not been so encyclopaedic. At first, when I photographed some new aspect of the view, I would feel as if I had discovered *something*. But gradually, *everything* began to seem a discovery. Everything was interesting, beautiful, and worth looking at.

I sometimes experience this same kind of positive creative energy when writing novels. Occasionally a chapter, a scene, or even a paragraph that I don't really feel like writing can feel like it is cut from a different cloth compared to the novel I am dreaming of. Writing becomes an effort, and I slow down, knowing that I must look at the world to find a dream or a memory more attuned to the spirit of my novel. But sometimes it feels as if the whole world and every thought that crosses my mind were especially designed to fit with the atmosphere of my novel. In these magical moments, every story I hear, every memory, everything that catches my eye, becomes a wondrous detail I must work into my novel. (I never find myself looking back and thinking I was mistaken, either.) This kind of optimism takes over me every time I come up with a fresh point of view, a new character, or a different narrative style with which to approach the story I want to tell.

The camera I had set up on my balcony had acquired a similar function to that of a new character in a novel. Every day I got up from my desk and took more and more pictures. There were times when my desire to take photographs seemed to overshadow my impulse to write. Or rather: the urge to take photographs had become a means of hiding from myself a number of woes, among which the fact that the novel wasn't turning out the way I wanted it to. Besides, there was so much that the camera on my balcony expected of me that perhaps for the time being it didn't matter that

I couldn't seem to write my novel in the way I had hoped, nor as much as I wanted to.

There was never any question, especially early on, of running out of things to photograph; in fact it was the opposite, with the view an inexhaustible source which would only expand as I photographed it. My brain had already started classifying the pictures I took and drawing up lists: like the cargo ships loaded with enormous containers of every colour; the city line ferries that went back and forth between Beşiktaş, Eminönü, Üsküdar, and Kadıköy; that distinctive light that appeared near Topkapı Palace, the Hagia Sophia, and in Sultanahmet and its environs; the changing texture of the sea; or the ships that sailed between the minarets of Cihangir Mosque and its dome... Whenever I sensed that something belonging to one of these categories was about to appear, I would run to the balcony. And if I happened to spot something in the view that I had never noticed before – perhaps in the way the light percolated through the clouds – I would add it to the catalogue of themes I wanted to explore in all their possible variations.

Within two weeks I had learned to recognise and record the plays and variations of light between the domes and clouds over Istanbul. Sometimes the light would fall in single, slender, triangular beams; or it would float down onto the sea and onto the Princes' Islands in silky, insubstantial layers, like some kind of semi-transparent veil. Shafts of light would slide eerily through the dark and cloudy sky on a winter's day, revealing the depth of the view. As I enthusiastically continued to take these photographs, I understood that the view before me was not some sort of wallpaper, uniform and one-dimensional, but that it was composed of a multitude of layers, each of varying density and depth, and spaces characterised by their own dimensions, texture, and light. In this ever-changing landscape of hills and slopes, of clouds on the horizon, of rare glimpses of Mount Uludağ (100 kilometres away) right after the lodos winds blew four times a year, of the Princes' Islands on the horizon (7 kilometres away), the Moda promontory, and the Topkapı Palace, right there in the midst of all this, was my balcony. The more I thought about it, the more photographs I took.

It's a simple calculation: I took a total of 8,500 photographs from the middle of December to the middle of April, which comes to an average of 70 photos a day during those 4 months. I spent

about 10 hours a day at my desk next to the balcony. So on average, I was taking 7 photos an hour – or rising from my desk for a new photograph every 8 minutes. But of course I would sometimes take lots of pictures one after the other, and sometimes I would forget about the camera for a while. The urge to go out on the balcony and take photographs did not necessarily arise at regular intervals.

Some days the clouds, the rays of light, the strange shadows, the birds, and the way the light played on the surface of the sea would keep me especially busy. Having registered the particular scene which had led me out of my chair and towards the camera in the first place, I wouldn't immediately return to my writing desk, but I would keep taking photographs of the subjects that populated the various categories in my head, such as the mountains in the distance, a red ship emerging into the Black Sea, or the strange silhouettes of the giant construction cranes on the Port of Haydarpaşa. Then I would photograph the same thing again, and one more time after that. I enjoyed repeatedly pressing the shutter release, and seeing every photo I took frozen for an instant in the viewfinder. Since the clouds, the ships, and everything else was always in constant motion, I knew that no two photographs I took would be the same.

Certain scenes – such as the view of the island of Yassıada in the distance – affected me so much that even if they contained no movement at all, I was happy to photograph them over and over again. The rhythmic clicking of the shutter release button was a pleasing melody to my ears. Every photograph I took, believing it to be 'beautiful', 'unique', and 'necessary', filled me with the same joy and satisfaction I felt when I added a pleasing sentence or paragraph to my novel. How wonderful it was to be taking these photographs! I wasn't wasting my time after all, here in this room, sitting at this desk. Sure, perhaps my novel wasn't quite coming along as I would have wanted it to, but someone had to take these photographs. I could return to my novel when I was done with them. I would worry about why I couldn't write my novel later, after the photographs. Sometimes I showed the pictures to my family and to my friends who came to visit me at the apartment, but I didn't take myself too seriously. I wasn't offended if they didn't seem particularly excited; after all, the view depicted in the photographs was right there in front of them. There was nothing

unusual about it. At most, they might marvel at the intensity in a shot of the cloudy, stormy sky from a few days before, or at the clarity of a night-time scene, or at the purplish hues that spread over the city sometimes just as the sun is about to rise.

Some days an orange glow would appear over the Marmara Sea. Sometimes the face of Cihangir Mosque would acquire an unusual tint. Sometimes a cluster of oddly shaped clouds would gather over Topkapı Palace. Some days I would admire the shades of colour on Nuruosmaniye Mosque. Sometimes I would stare raptly at a freight ship making a sharp and risky turn. Sometimes – often, in fact – the sight of a ship gliding towards me through the morning mist would move me. I felt I was taking these photographs in order to explore some state of mind I couldn't fully comprehend. Directed by a kind of awe and fascination, my finger found the shutter release button with increasing frequency. Click, click, click, and three more landscape photographs later, I felt immediately better.

The more I went on, the less time I spent looking at the photographs I was taking, and the less I showed them to anyone else either. When I was little, buying a roll of film and later getting it developed at the neighbourhood Kodak shop was an expensive and time-consuming undertaking. Since every photograph cost money, I would spend an awful lot of time thinking about the subject of each frame, the lighting, the angle of the camera, and making sure I got everything just right before I pressed the button. A bad, poorly constructed photograph was a waste of money. My first digital camera went some way towards easing that childhood fear of taking a bad photograph, but even with that camera I would still press the shutter release with some trepidation. The new camera on my balcony swept these old habits and misgivings away, even though I still took each landscape photograph with the utmost care and commitment, and with my whole being attuned to the view, just as I used to do in my boyhood and youth. I would take a photograph, then another, and another. Just before sitting back down at my desk, I would take one more.

I was slightly embarrassed by the number of photographs I was taking, how similar they all were, and how much time I was devoting to this amateur endeavour, so I quickly grew reluctant to show anyone else my pictures. Even I rarely looked at them anymore, despite the fact that I actually liked what I was producing. I heard the

same question I used to hear about the endless pictures I took with my first digital camera now being asked about the photographs I was taking from my balcony:

'Look at all these photographs! What are you going to do with them?'

I had no answer to that. It was no longer necessary to get the photos developed in order to see them. It was easy enough to examine them all, one after the other, on the little screen on the back of my Canon camera. I would do this every now and then, and conclude that I'd taken some good photos, but still I never thought about what I might do with them. Very few people knew I was even taking these pictures, and no one offered to display or to publish them. I would have immediately rejected such an offer anyway, on the grounds that it would have interfered with the spontaneous, instinctive nature of what I was trying to do. I didn't want to see these photos on paper. Maybe the reason I was so comfortable taking all these pictures, and why I was so pleased with how they looked, was that I knew no one except me would ever see them.

I had no idea what I would do with the photographs I took, but I still wanted them to be an 'exhaustive', 'flawless', and complete record of what I saw. I would hurry from my desk to the camera sometimes only to find that the batteries had run out, and knowing what this meant – that I would have to let the indispensable image of some rusty, woebegone ship sailing beneath a black cloud slip me by unrecorded – I would experience a pang of suffering. This emotion, which I began to develop towards the end of January, was similar to regret, and almost identical to the feelings of a true collector (the kind who keeps adding to their collection without quite knowing why) upon realising they are about to miss out on a coveted item. What drove me now was the determination to complete all the imaginary series in my mind, like the 'city line ferries' series, or the 'rusty ships with black smoke coming out of their chimneys' series.

What eventually slowed me down may have been the knowledge that this ambitious, encyclopaedic photographic endeavour was perhaps too vast to ever be completed. I was gradually coming to terms with the impossibility of recording everything that was beautiful and worthy of being recorded. And the beauty, the necessity of the photographs I was taking, as well as the pride I felt for

having taken them, were no longer enough to suppress the sense of desolation I felt. In other words, even taking photographs was no longer helping to deflect the question of why I couldn't seem to write my novel as I would have wanted to.

Halfway through the winter, I began asking myself a question I hadn't thought of in the weeks before: 'Why am I taking these photographs?'

I could have said 'Because I want to have a picture of every ship that passes by with black smoke coming out of its black chimney!', but I knew that wasn't right. Soon the nature of the question itself changed: 'Why am I taking photos of this solitary ship sailing in from afar on this day when the line of the horizon seems hardly there?' I had always known the answer in theory. But now I was actually experiencing it in practice, and understood it in a more concrete way: 'There is something in this view which reflects my own state of mind and reveals the ineffable but profound emotions running through me.' I realise that this statement only partially addresses the complex relationship between a landscape and those who observe, paint, or photograph it. And I wasn't just taking these photographs because I recognised my own sorrow in the landscape; I was also doing it because I was enthralled by the multitude of functions on my new camera, and they distracted me from my melancholy state.

I spent a lot of time out on the balcony as the end of winter approached, working to capture all the strange scenes that had emerged in the aftermath of two blizzards that had hit the city in quick succession. One morning I saw an almost tangible bank of fog rolling down the Bosphorus from the direction of the Black Sea. Some days I would wake up unprompted at sunrise, and on seeing something unexpected in the misty landscape, I would head straight for the balcony.

At the first signs of spring, I began to see blues, greens, and oranges that had been absent during the winter months. One sunny, glittering morning, I did not go out on my balcony to take photos. It was a yellow and navy blue, bright and multi-coloured Sunday, and the boats from the Marmara Yacht Club had unfurled their sails in the water off the Moda shore, thereby announcing the end of winter and of sorrow. I did emerge onto the balcony later to take a few pictures, but without feeling any great urge to do so. I

had gone back to my novel now, back to walking down the streets of Istanbul with my characters. For a time, I forgot about my new camera on the balcony and my landscape photographs.

I returned to those images again five years later for the purposes of this book, and it was invigorating to go through them all again. For the first time, I got to see them on a computer screen, in full depth and detail. It felt as if all the forgotten memories from that period of my life had suddenly resurfaced. In the time that had elapsed, every photograph seemed to have transformed into a sign of my dark, dismal mood of those weeks.

But I also discovered things I had failed to see back then: despite the shared atmosphere that connected them all, every day that I had photographed was of a different hue which I had never noticed at the time. I had also forgotten how many birds I'd photographed, how I had tried to peer into the interiors of ships and neighbouring homes, how I had kept taking photos even in the middle of the night or at daybreak, like a sleepwalker.

As I put together a selection of images for this book, I realised it was going to be very difficult to forgo any of the photographs I had taken. Eventually I decided that I shouldn't just pick the best shots, but that I should also seek to show how I had been feeling in that moment, why I had grown attached to a particular view, how certain scenes were repeated, and the subtle shifts between each image. If this book was to be as much about the state of my soul as it was about landscapes, it followed that I should order the photographs chronologically, as if I were telling a story. Accordingly, it made more sense for the book to be set up in portrait format even though all of the photographs had been taken in landscape format, and for most pages to contain more than one photograph. Once I'd made these initial decisions, it wasn't too difficult to figure out where and how to place each image.

When I was about to complete my memoir *Istanbul*, I realised that I could have chosen a completely different set of memories and anecdotes to write about and still ended up with exactly the same book. I felt the same way while working on *Balkon*: I could have selected an entirely different 568 photographs from my archives to tell the story of the winter of 2012, but the overall effect of that book, the emotions it would have evoked in those that perused it, would not have differed in the slightest from what this book achieves.

I would like to thank Gerhard Steidl for his interest in these photographs which, despite the quantity of photographs I still take today, had previously been languishing in my archives. If it hadn't been for Gerhard's keen eye, they would have remained neglected by the world (myself included), and nobody would have thought of publishing them in physical form. To those who ask me why I took these photographs in the first place, I can now safely say this: to see them in print, on paper, inside this book.

December 2017, Istanbul

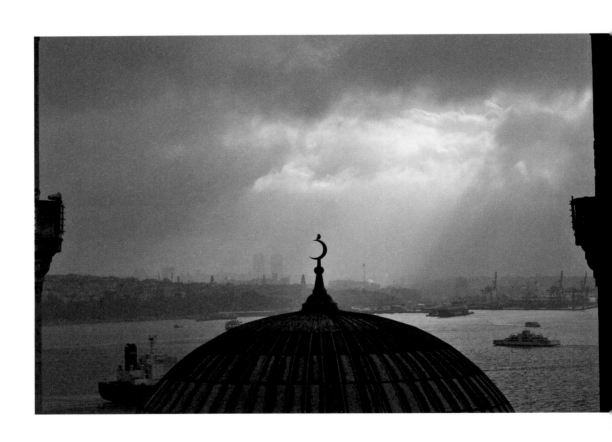

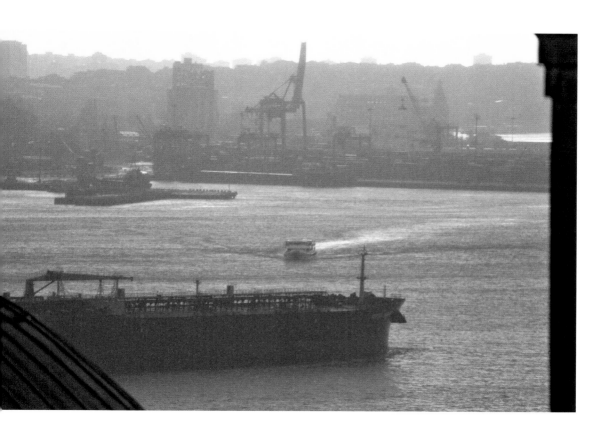

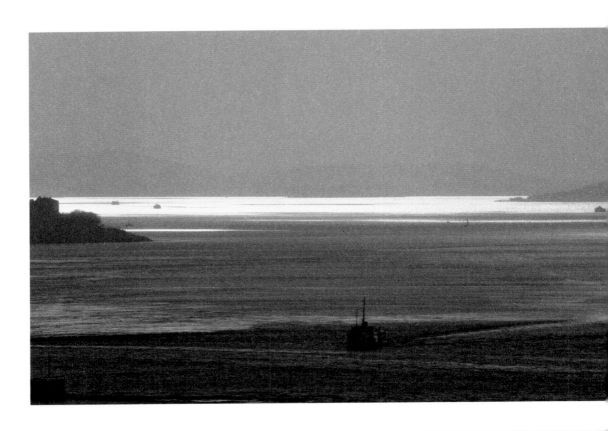

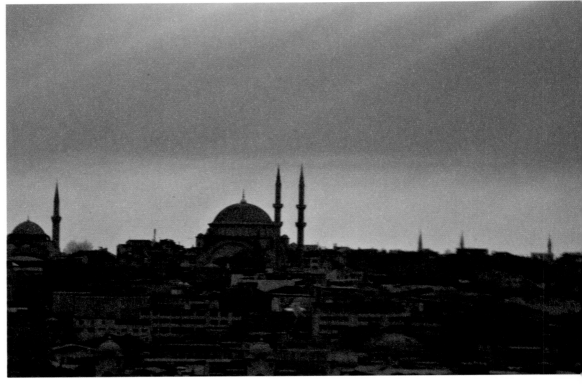

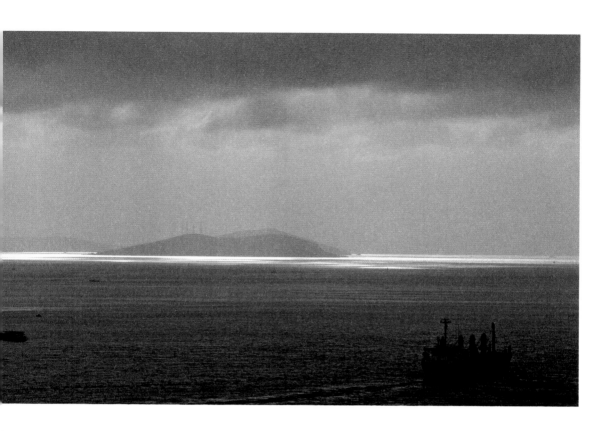

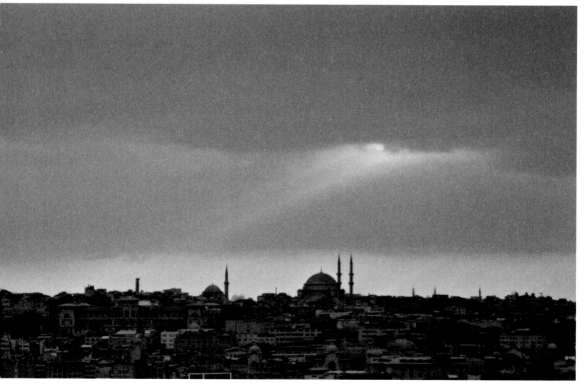

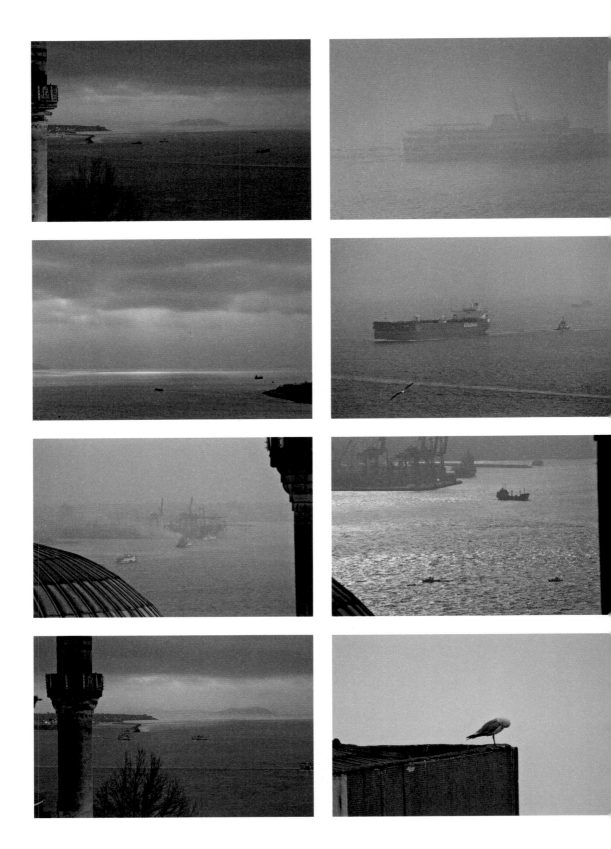

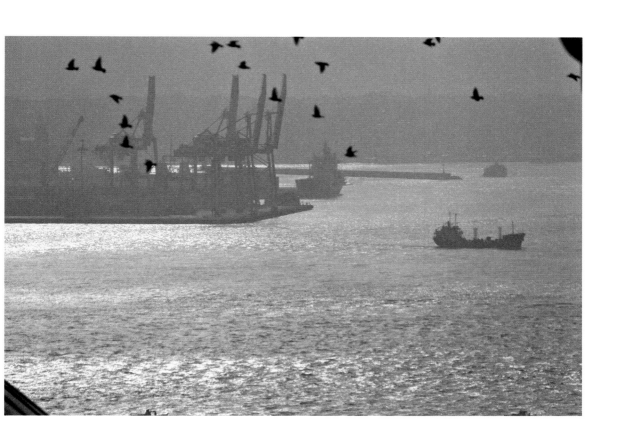

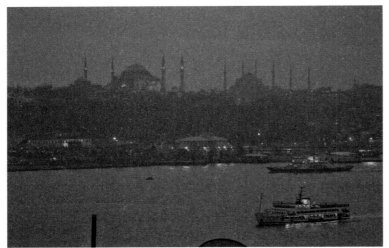

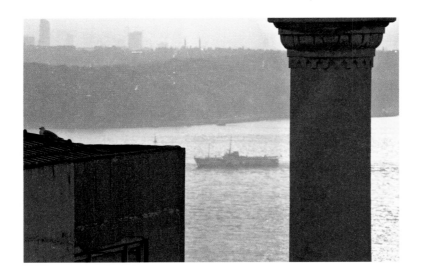

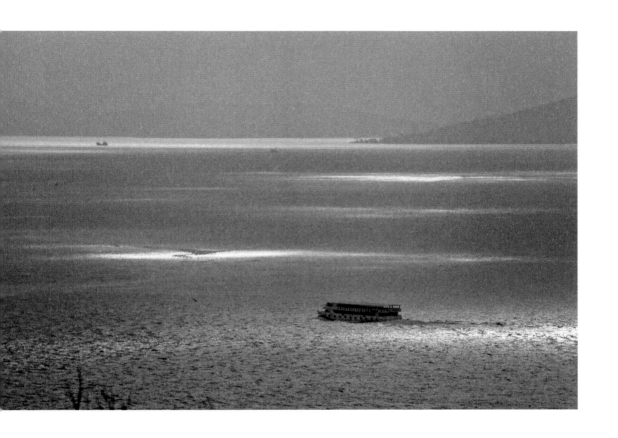

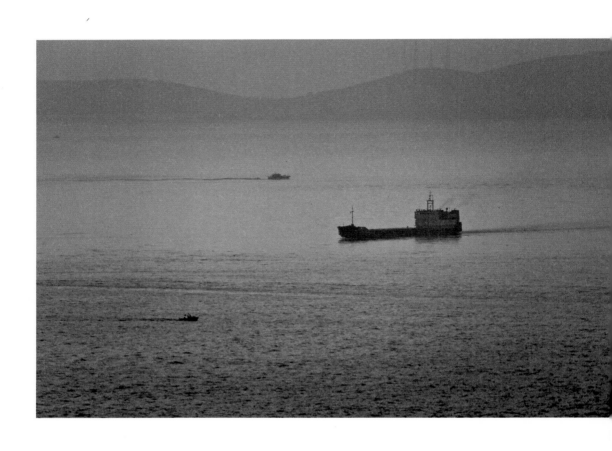

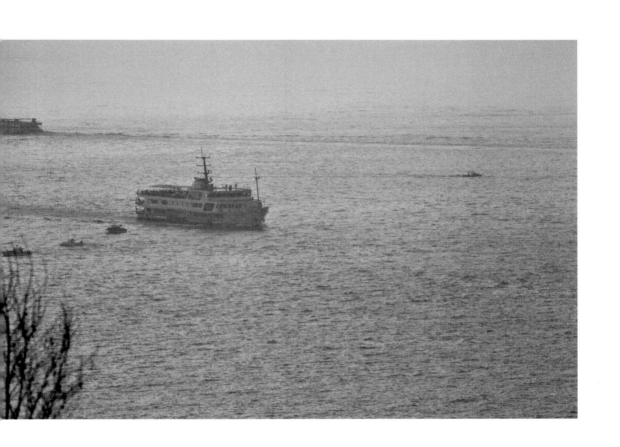

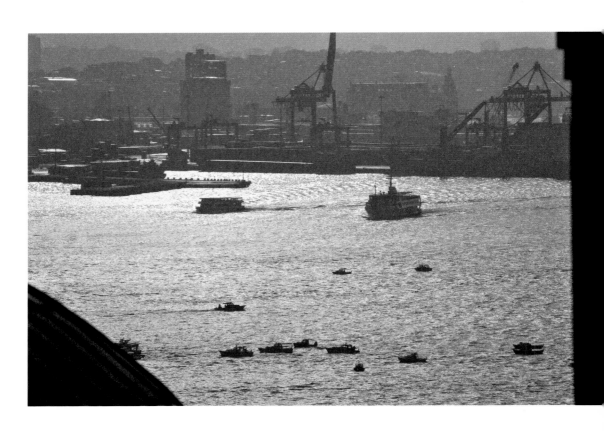

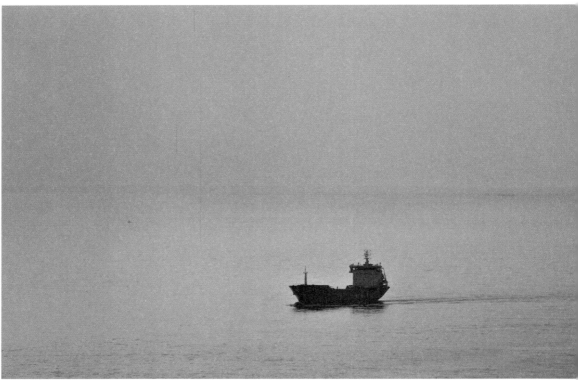

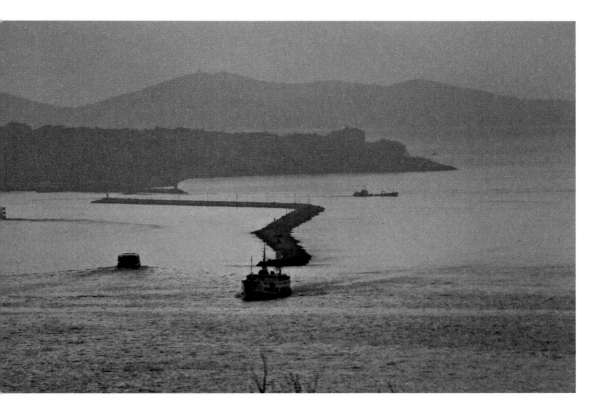

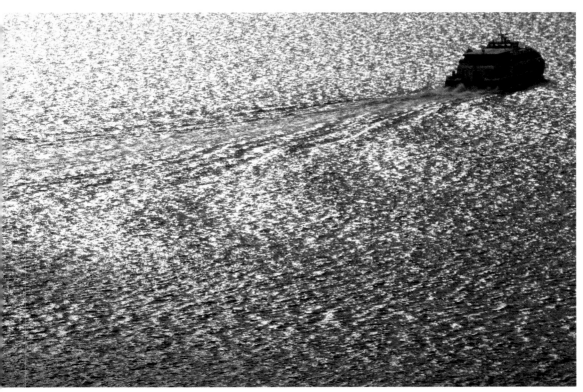

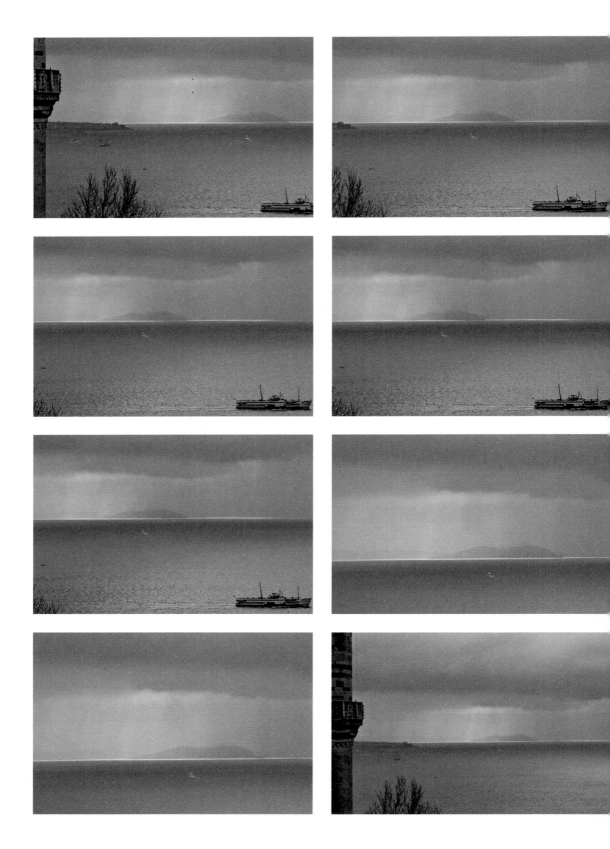

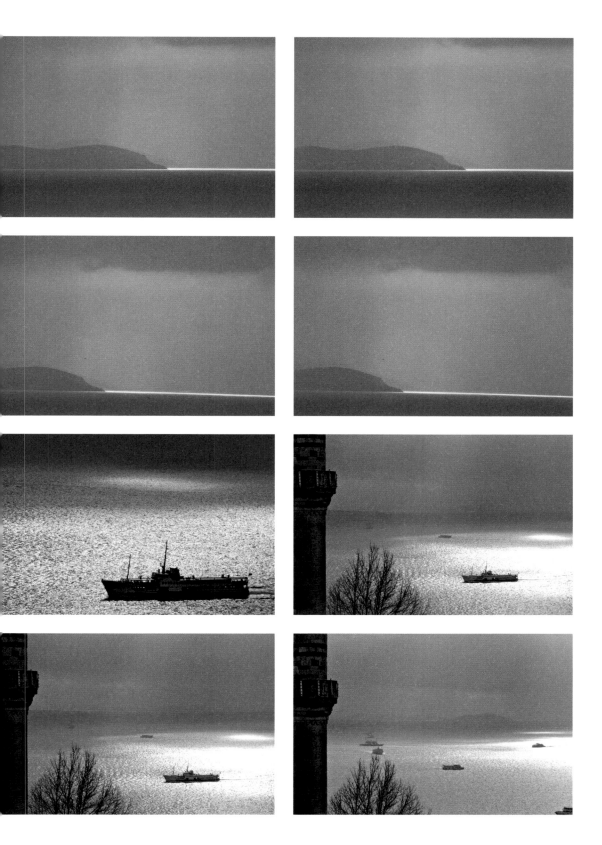

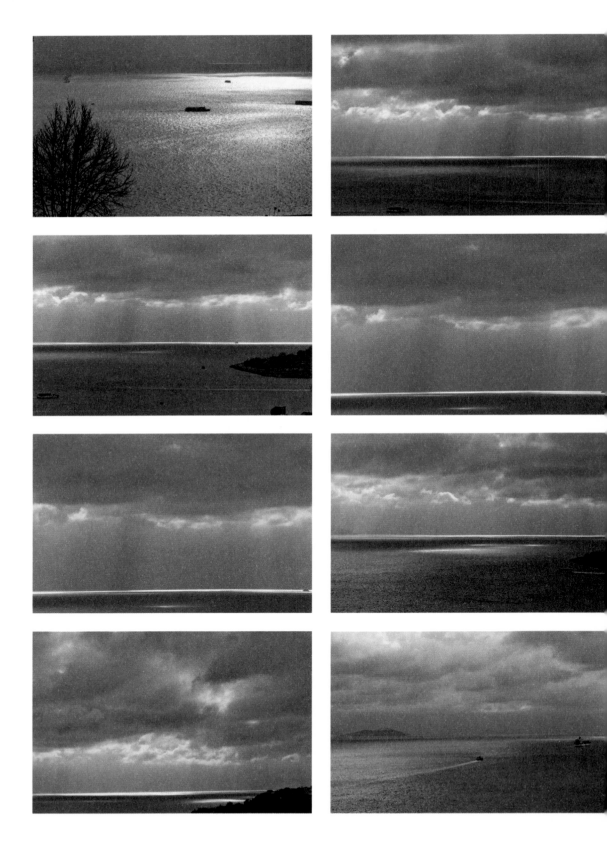

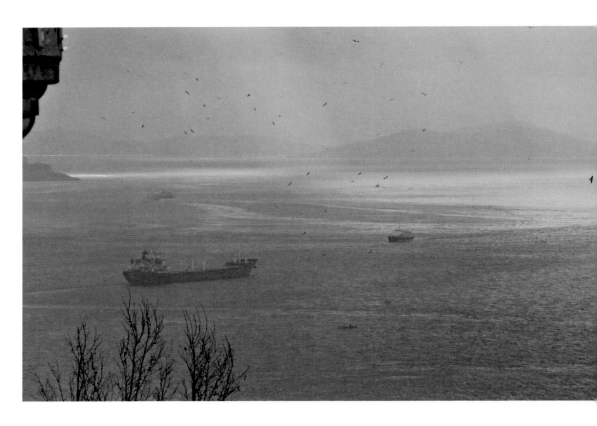

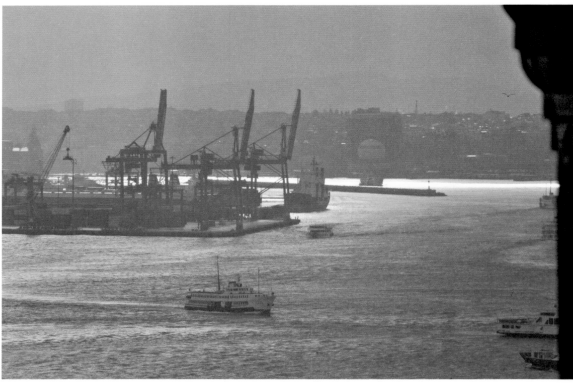

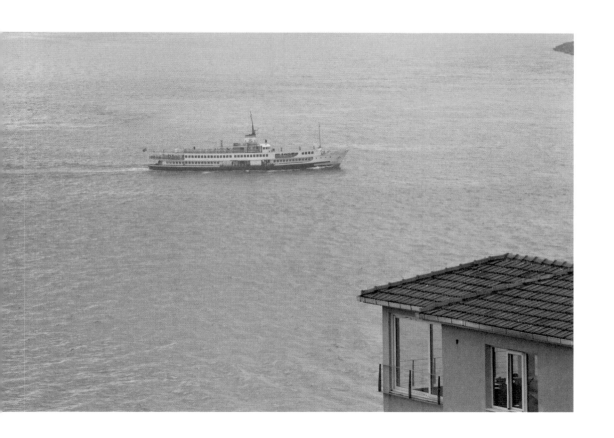

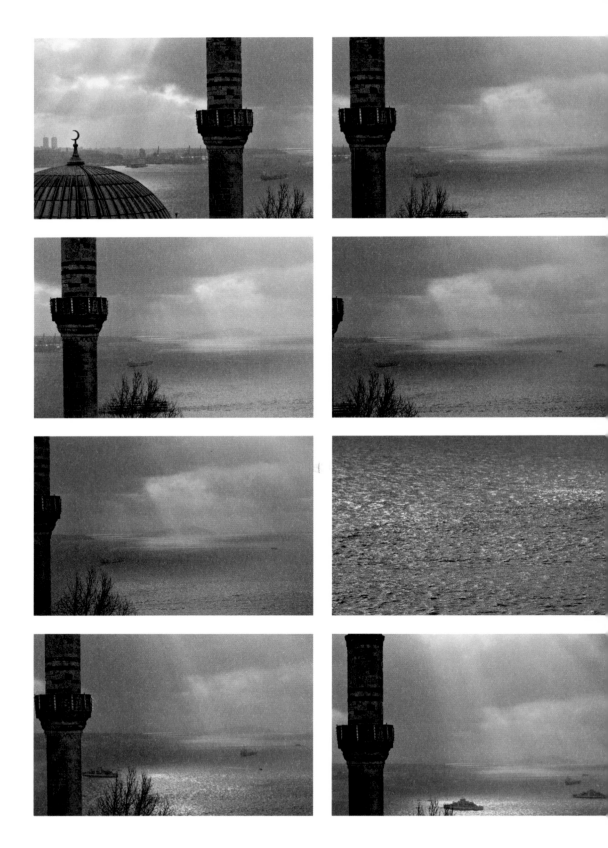

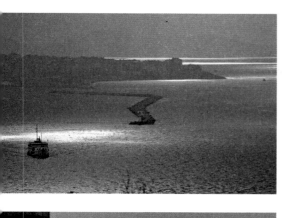
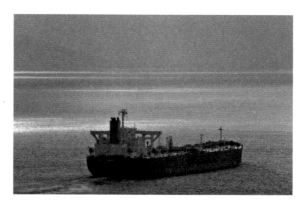
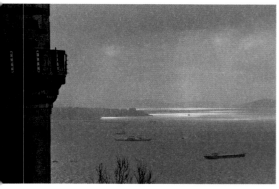
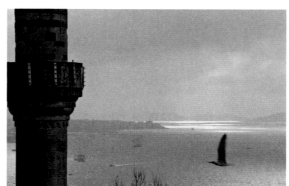
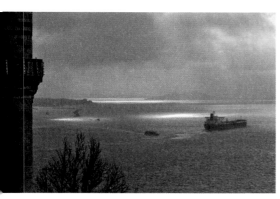
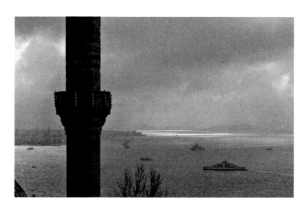
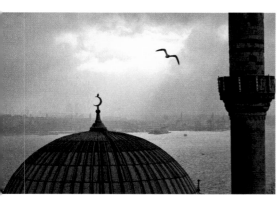
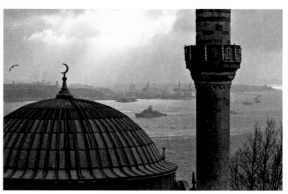

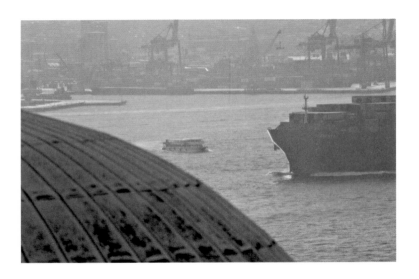

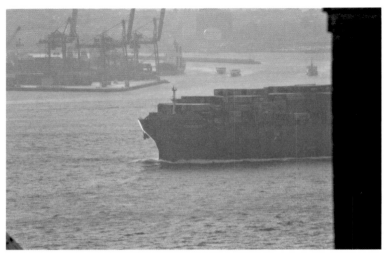

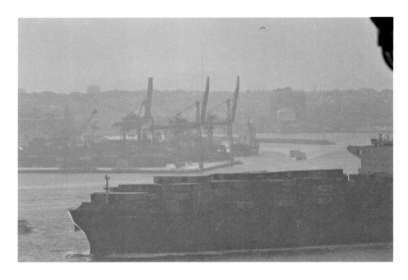

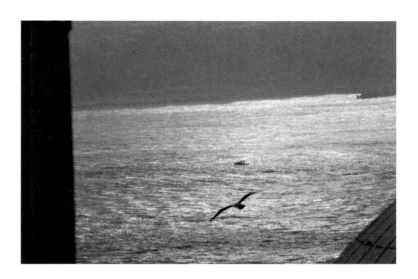

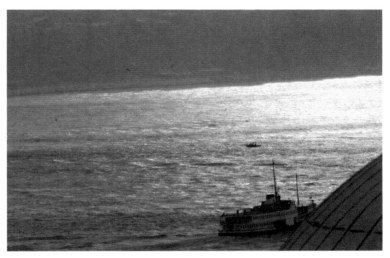

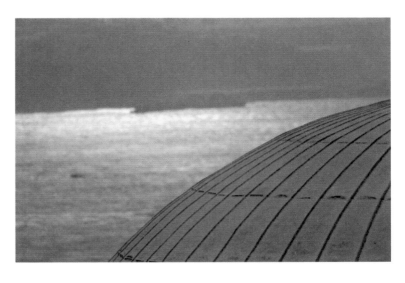

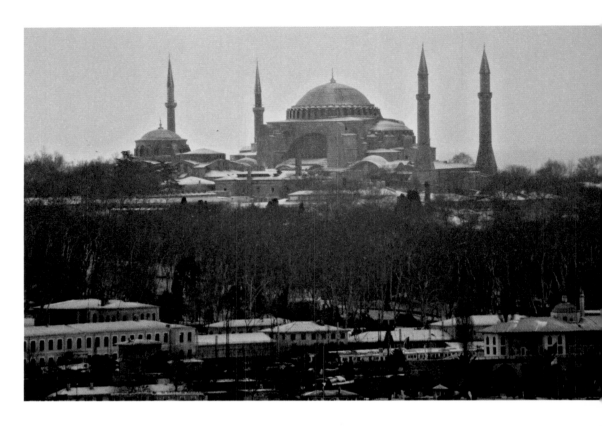

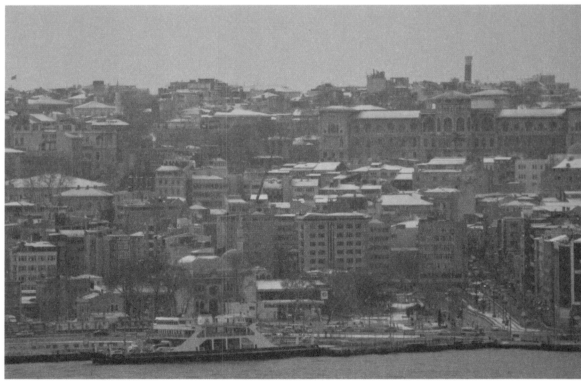

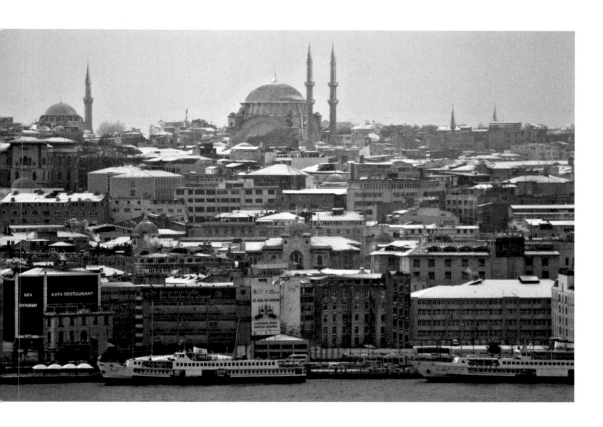

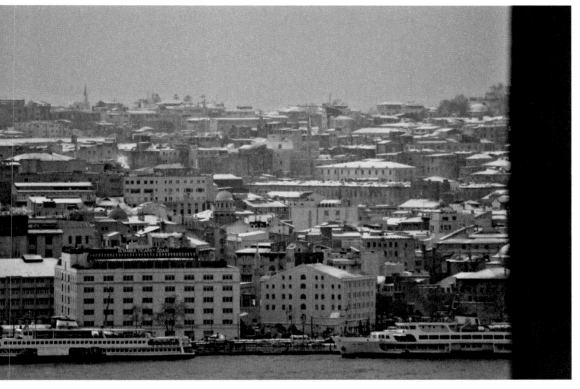

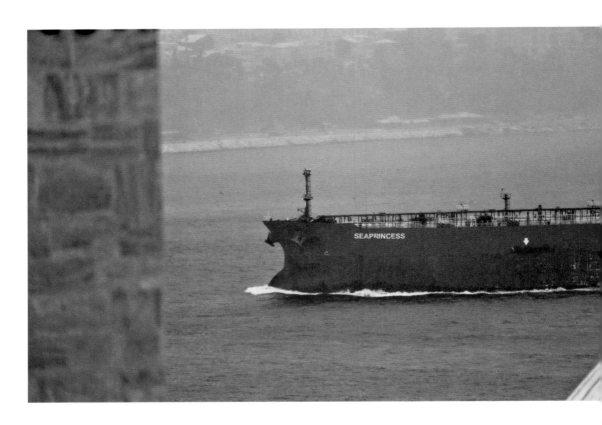

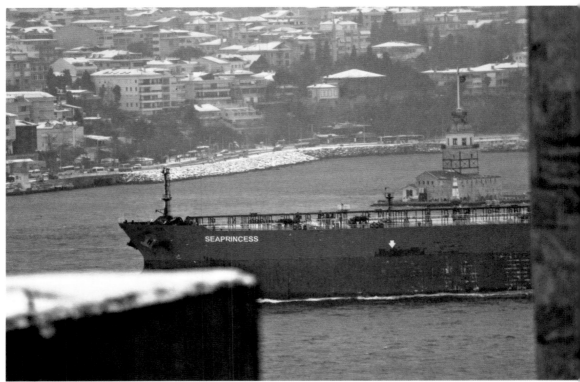

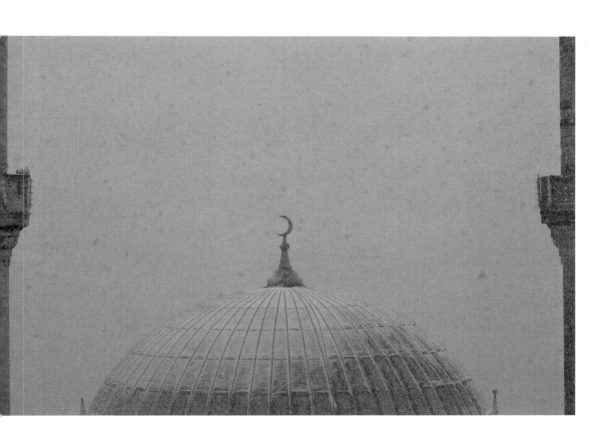

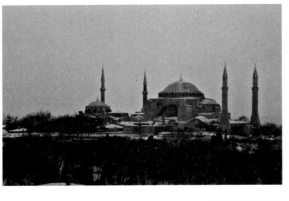

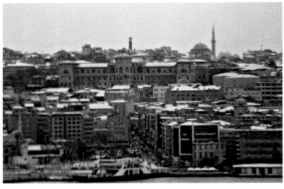
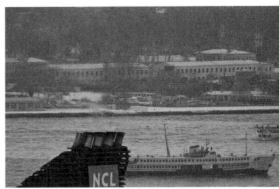
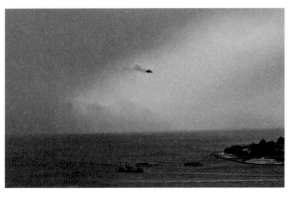

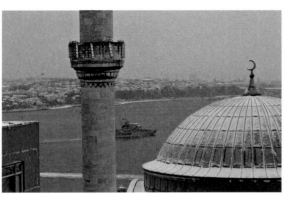
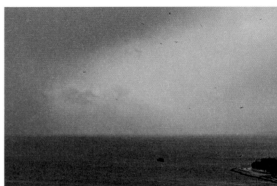

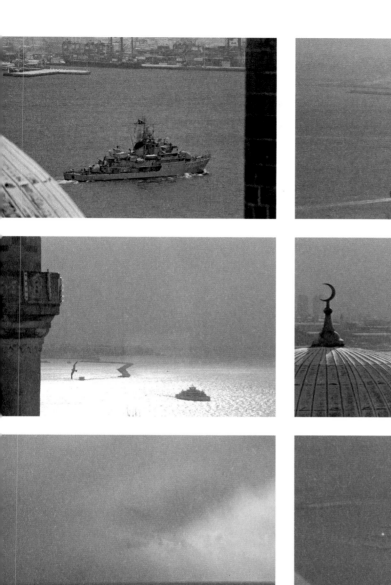
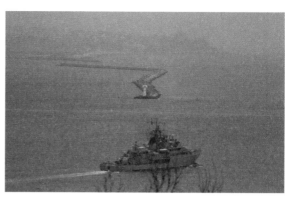
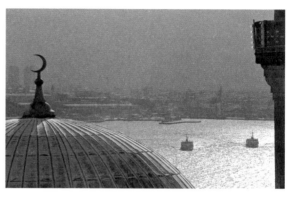
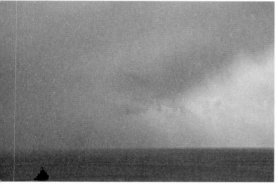

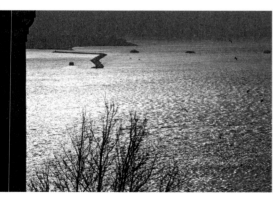
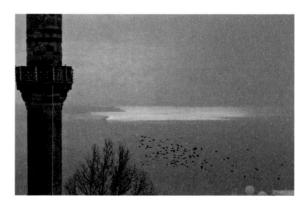

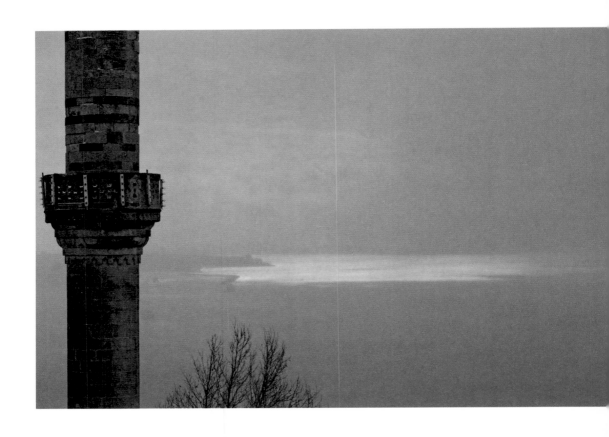

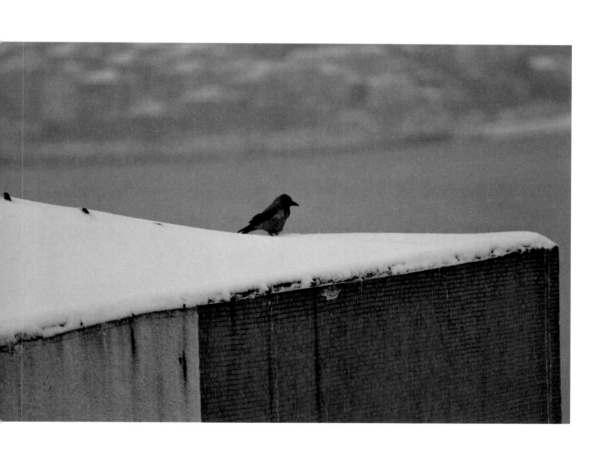

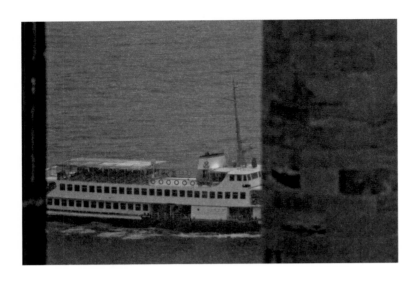

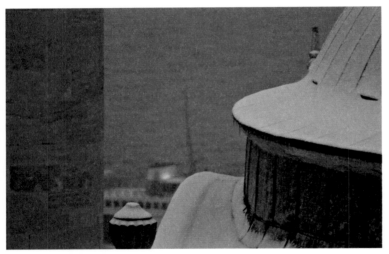

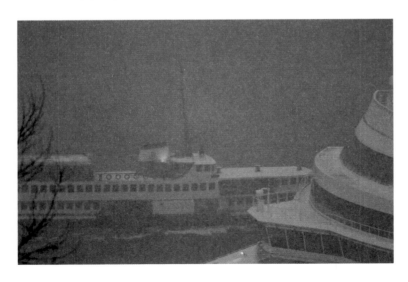

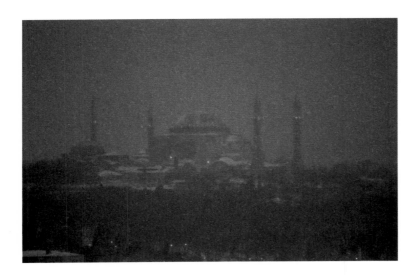

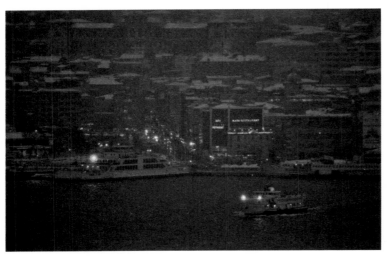

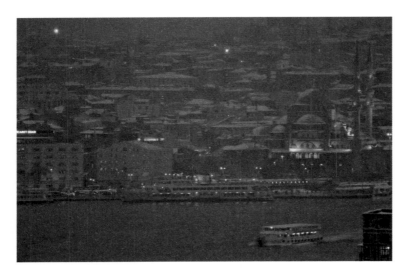

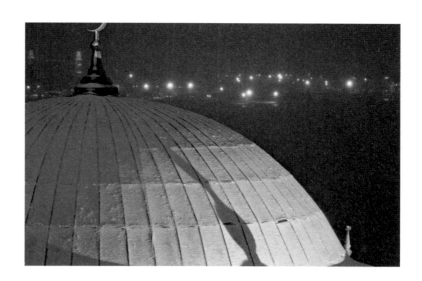

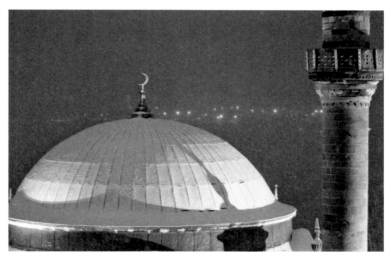

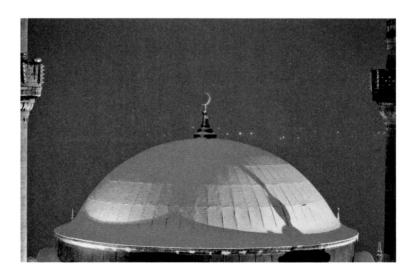

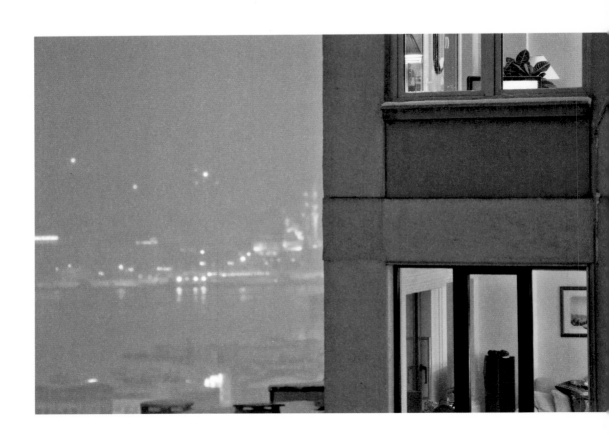

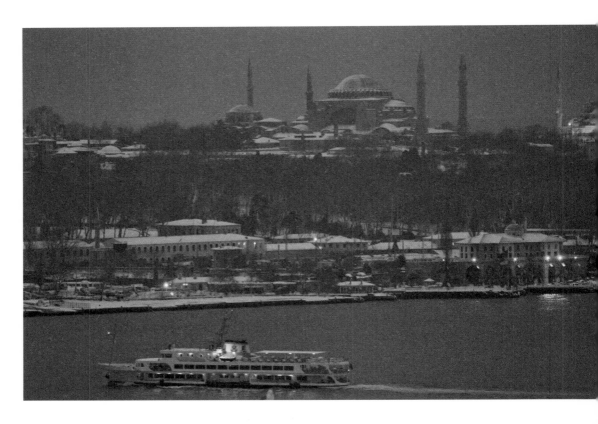

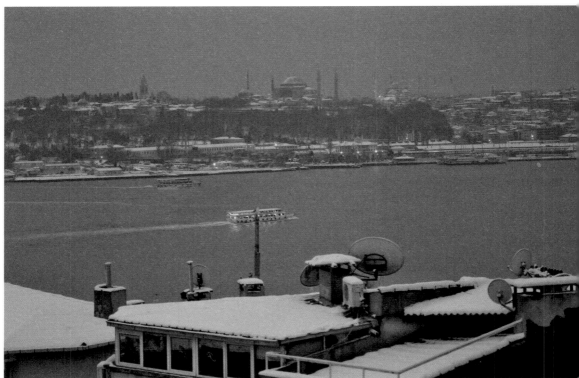

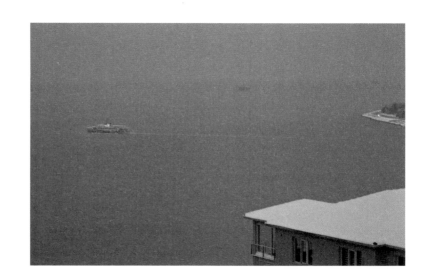

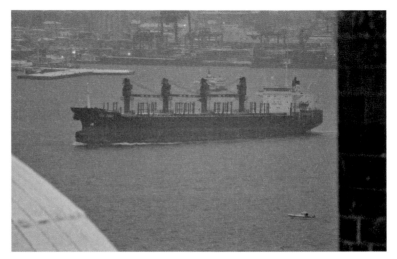

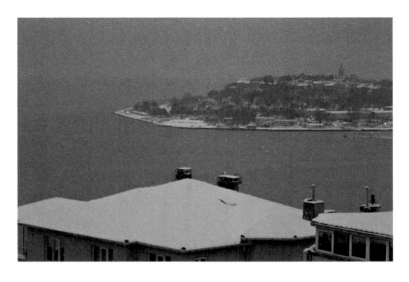

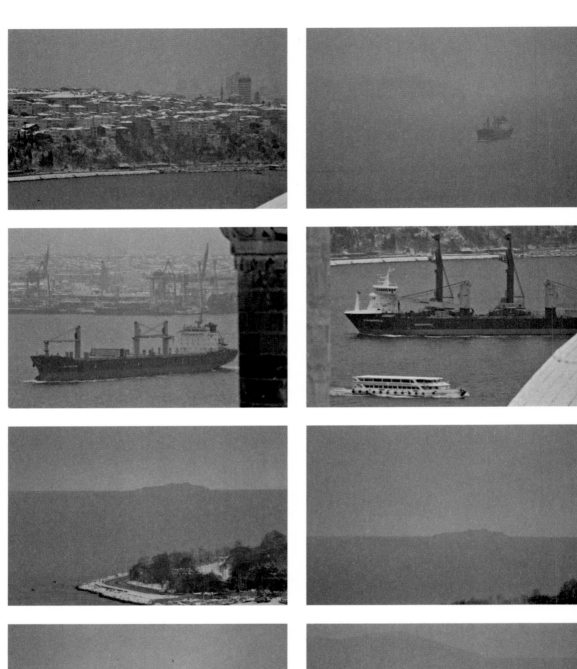
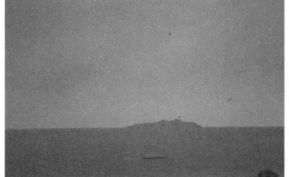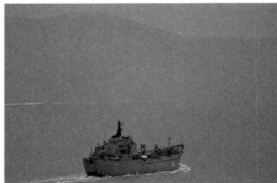

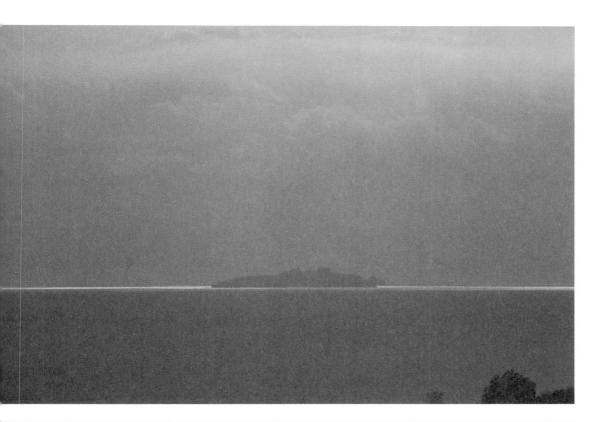

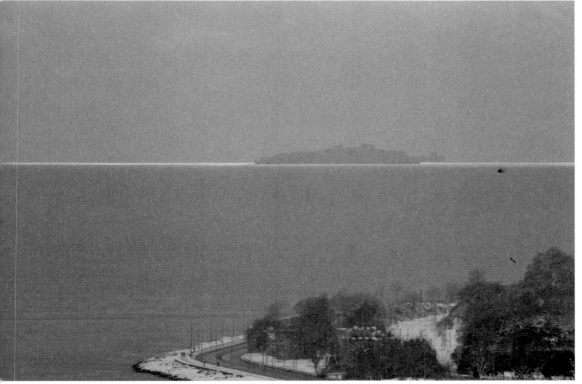

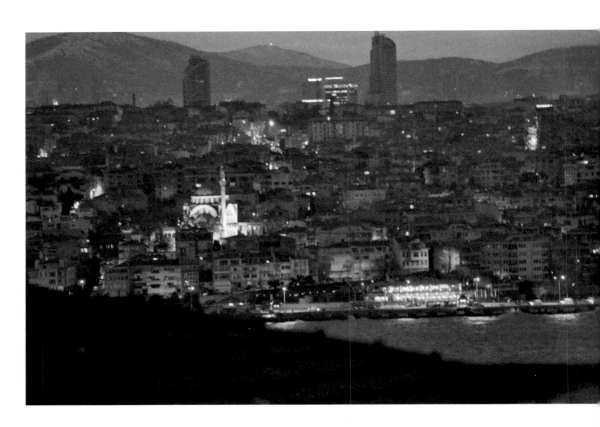

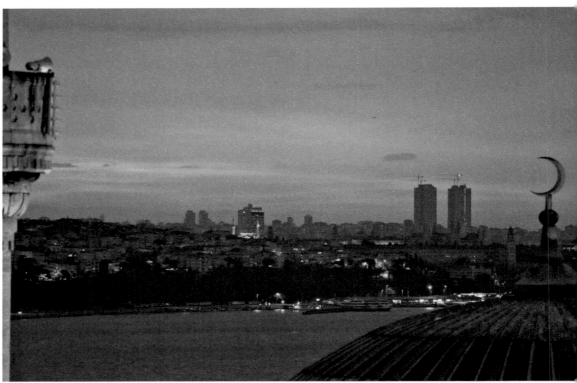

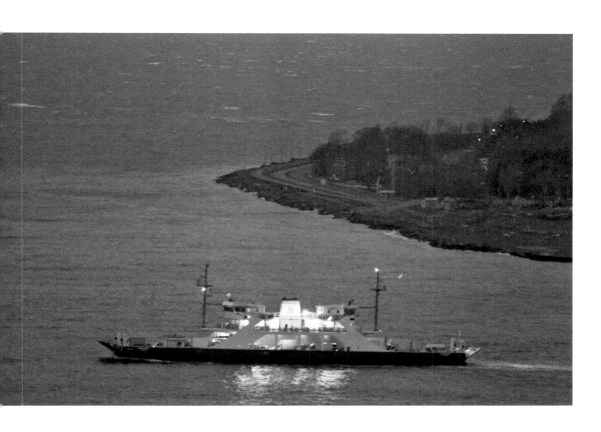

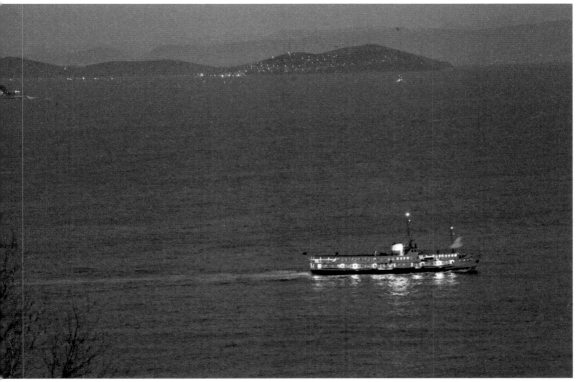

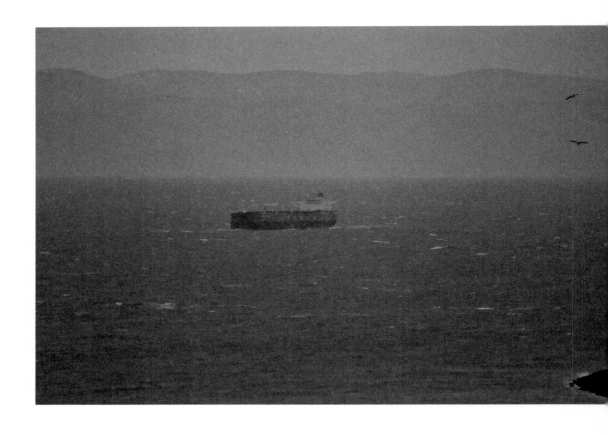

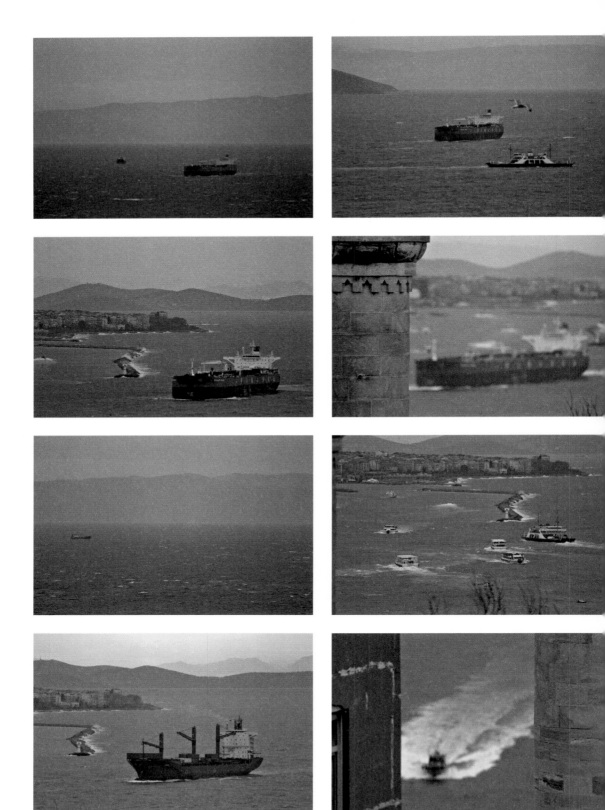

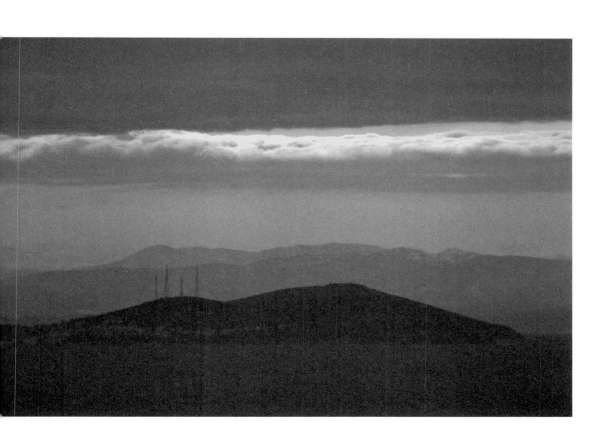

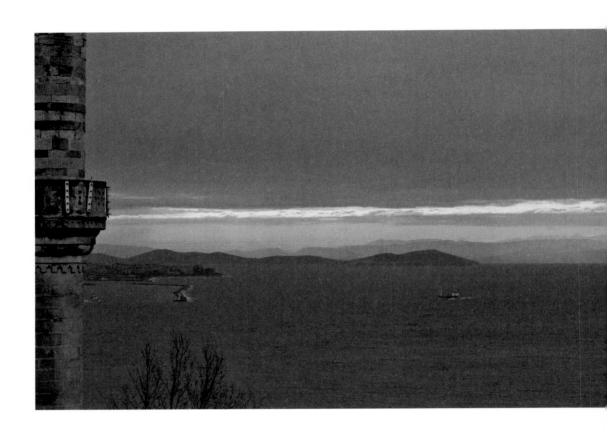

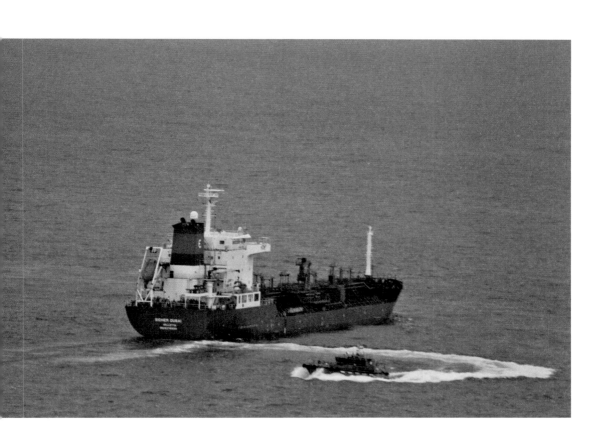

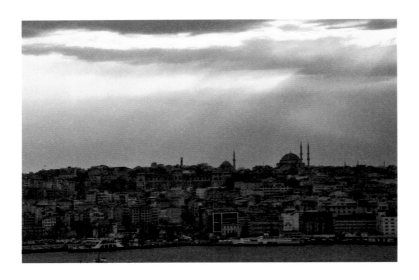

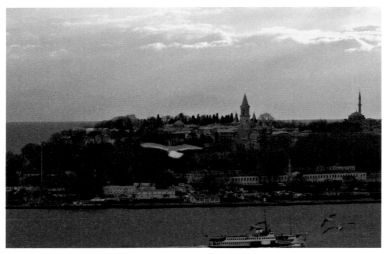

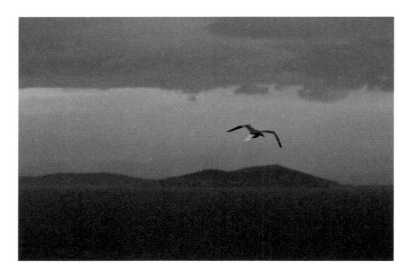

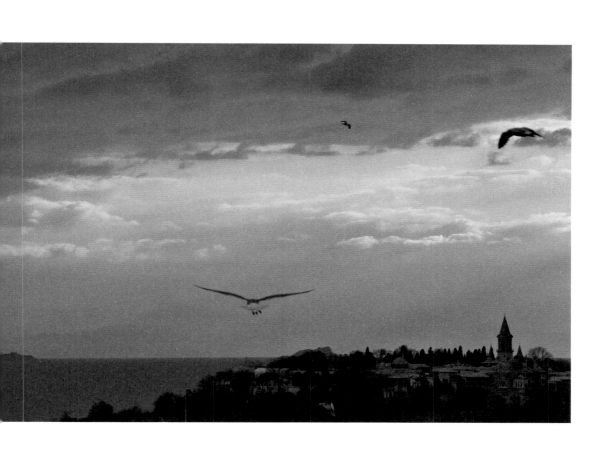

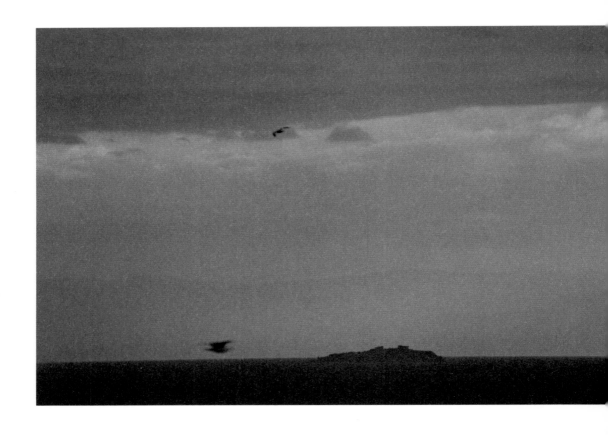

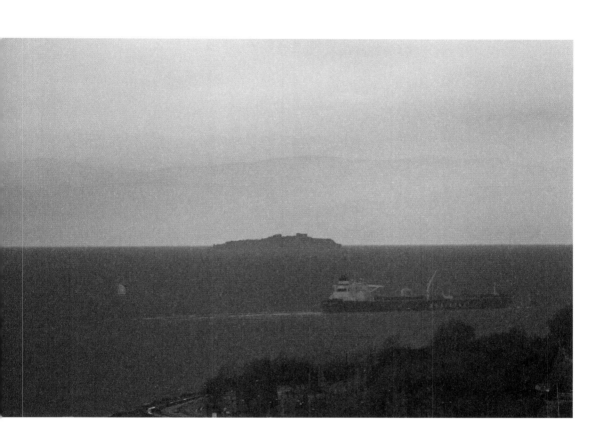

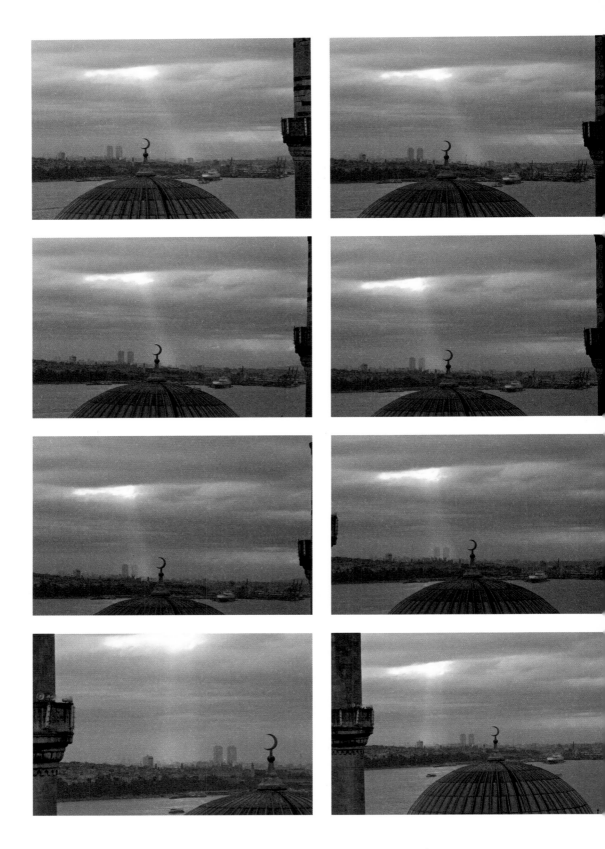

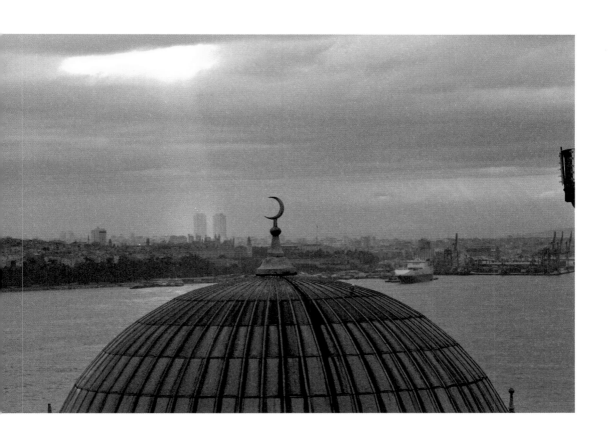

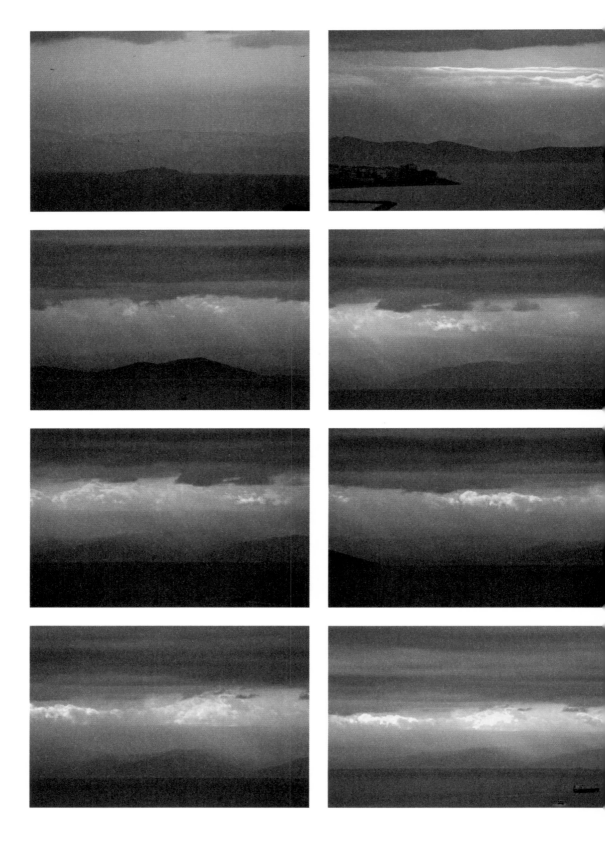

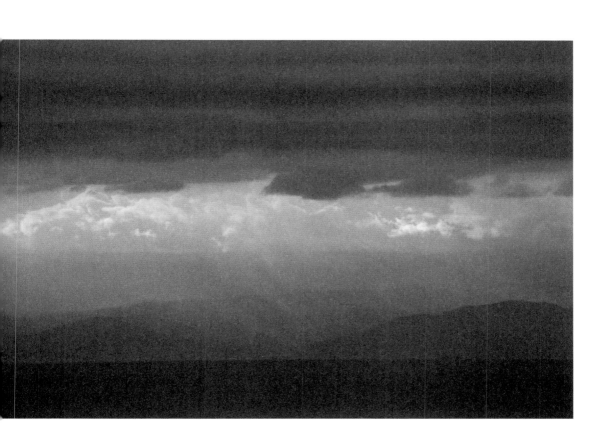

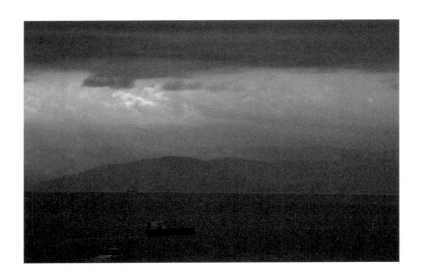

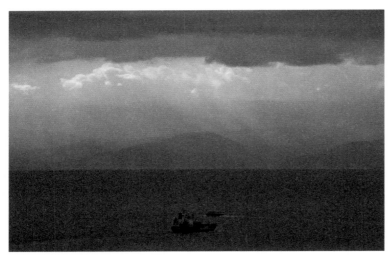

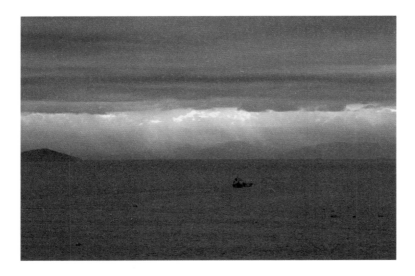

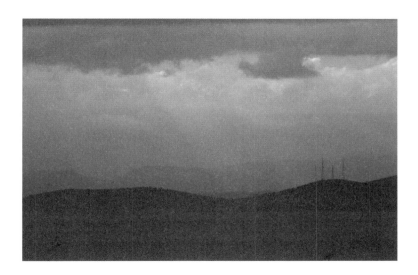

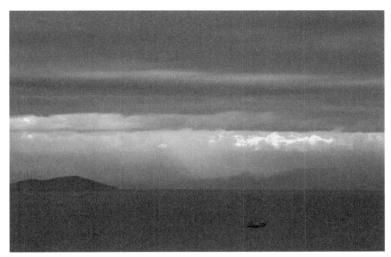

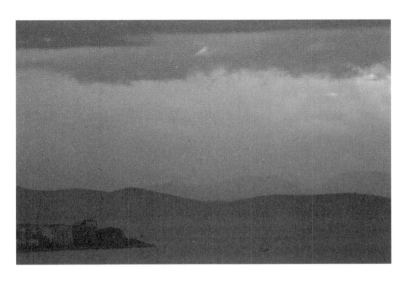

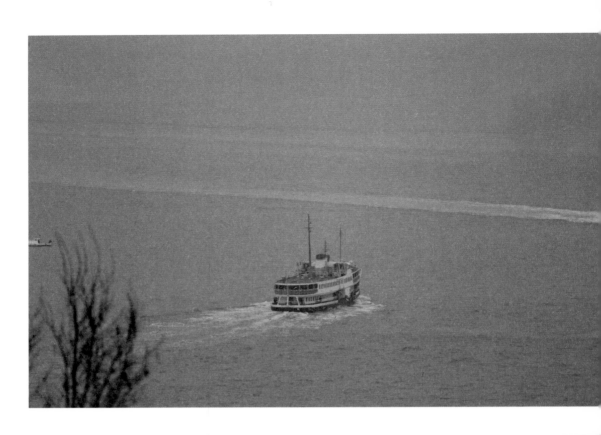

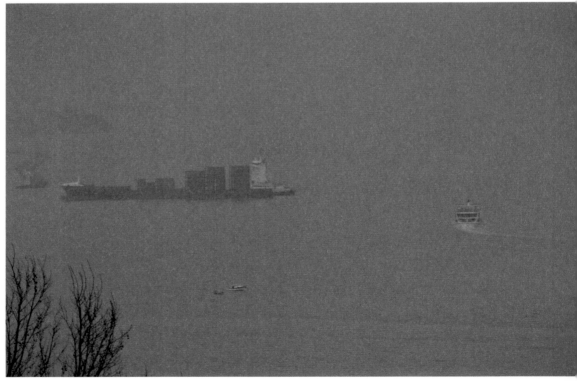

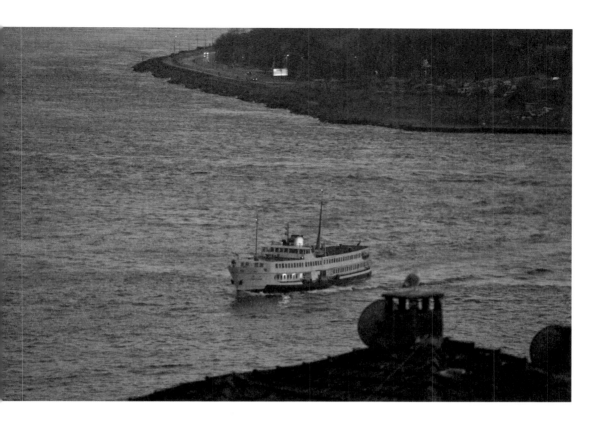

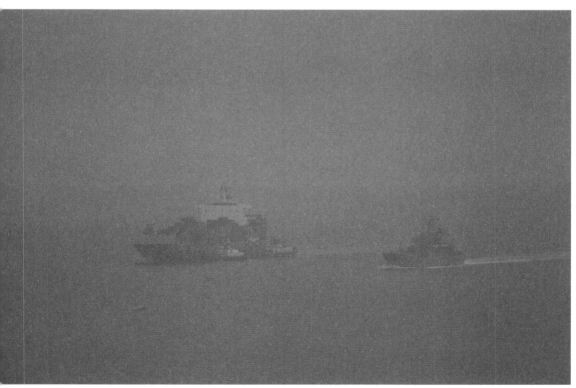

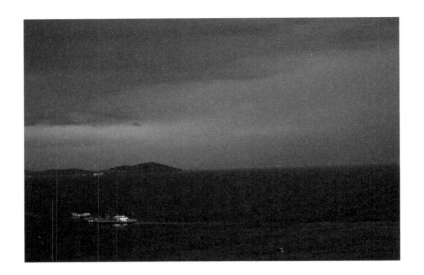

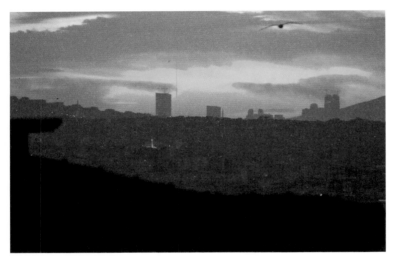

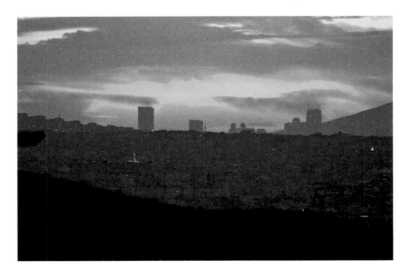

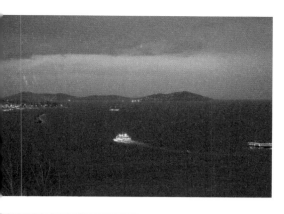 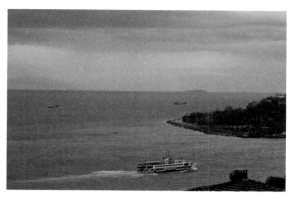

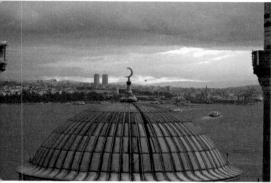 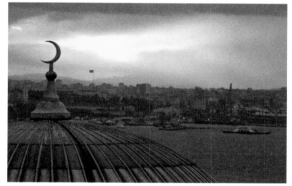

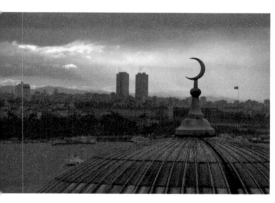 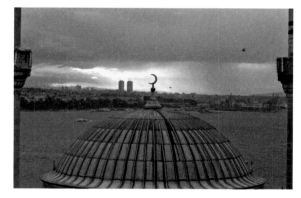

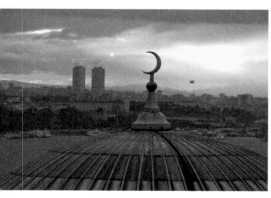 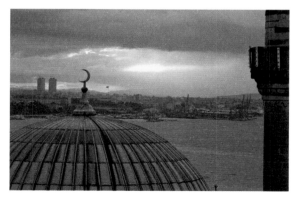

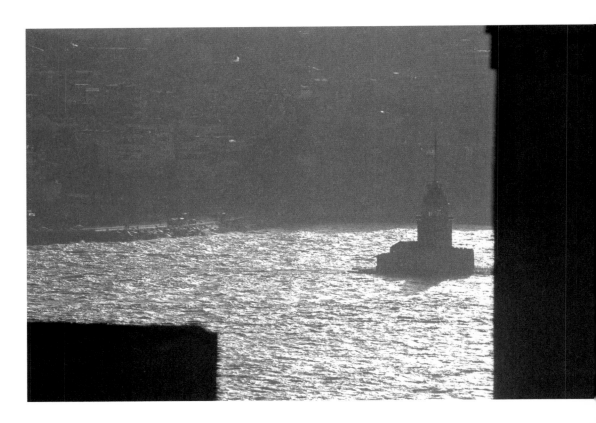

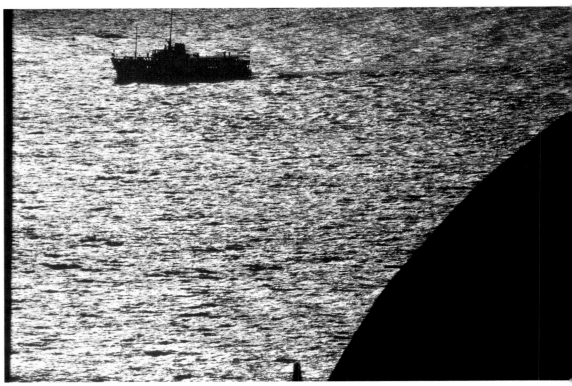

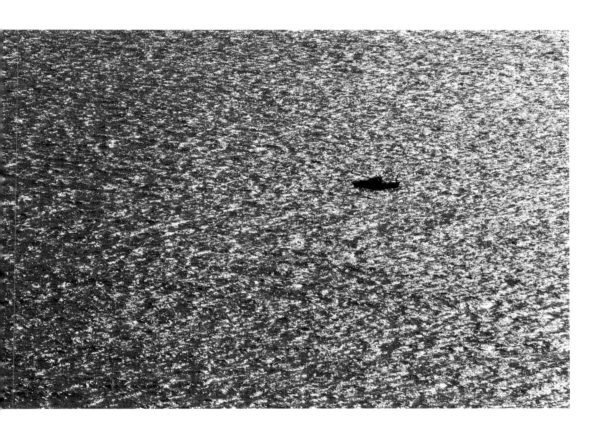

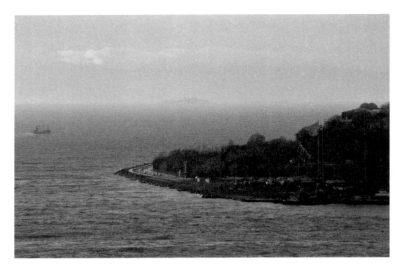

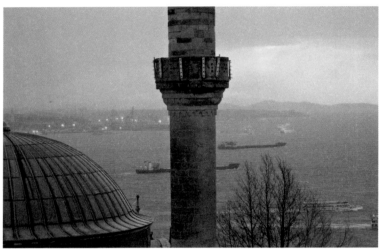

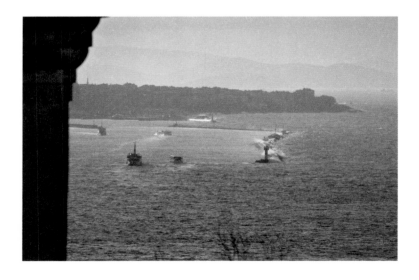

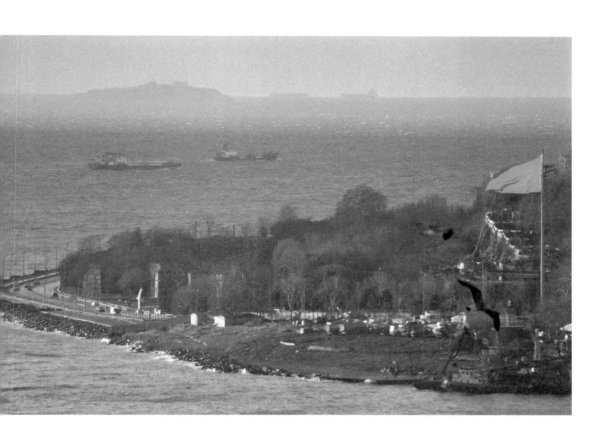

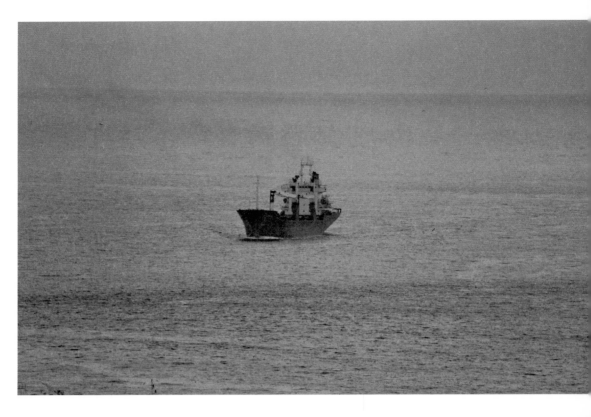

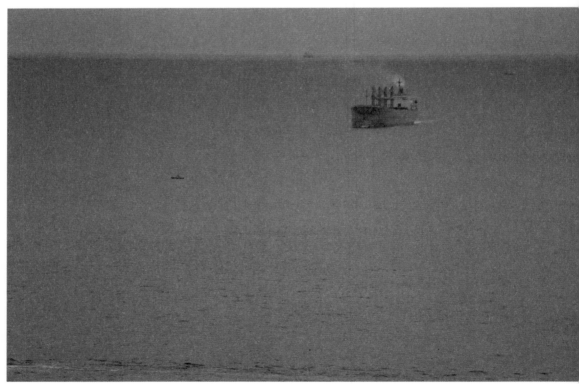

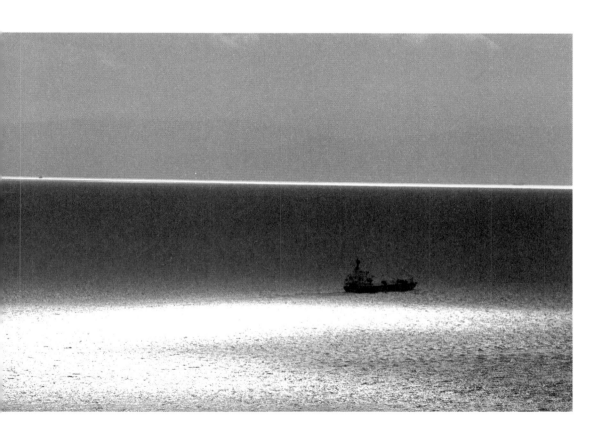

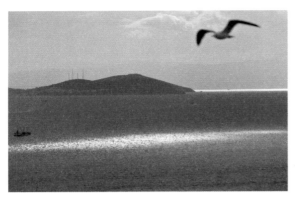
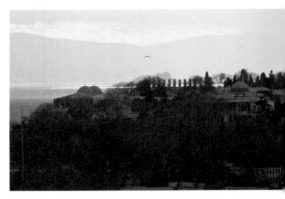
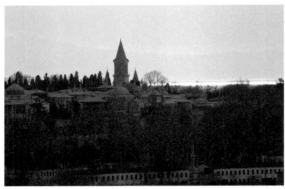
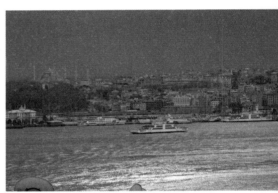
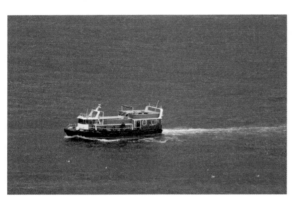
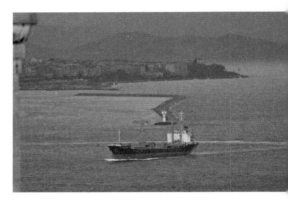
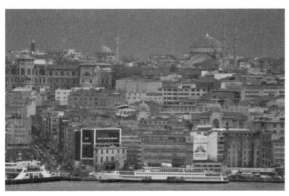
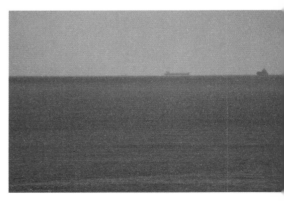

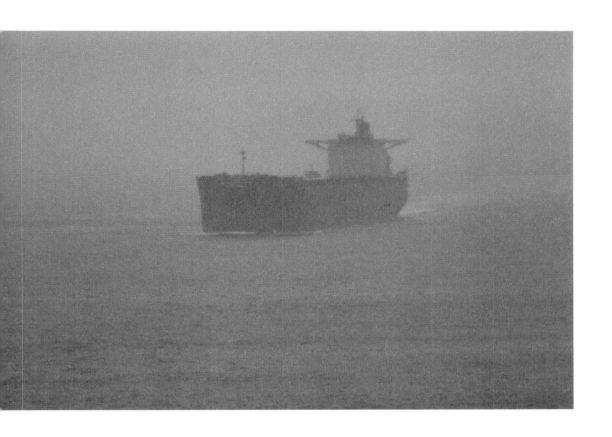

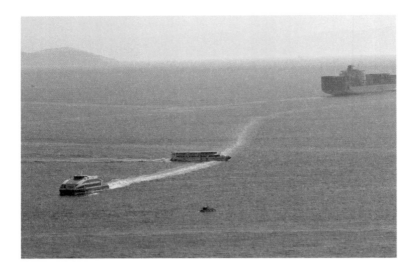

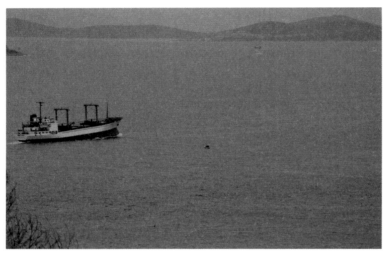

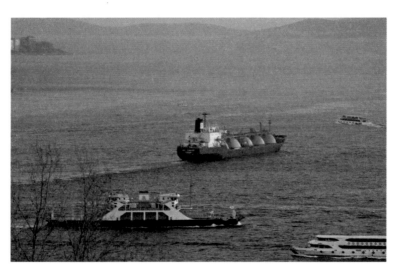

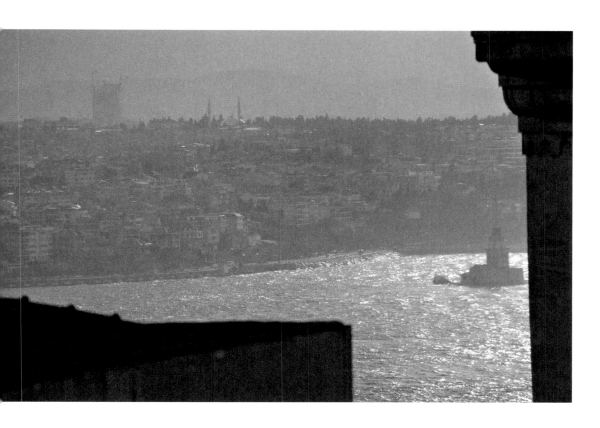

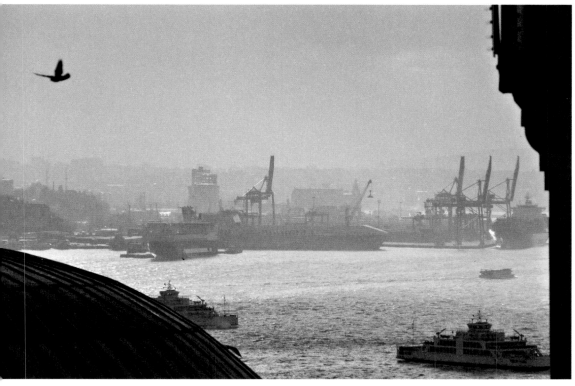

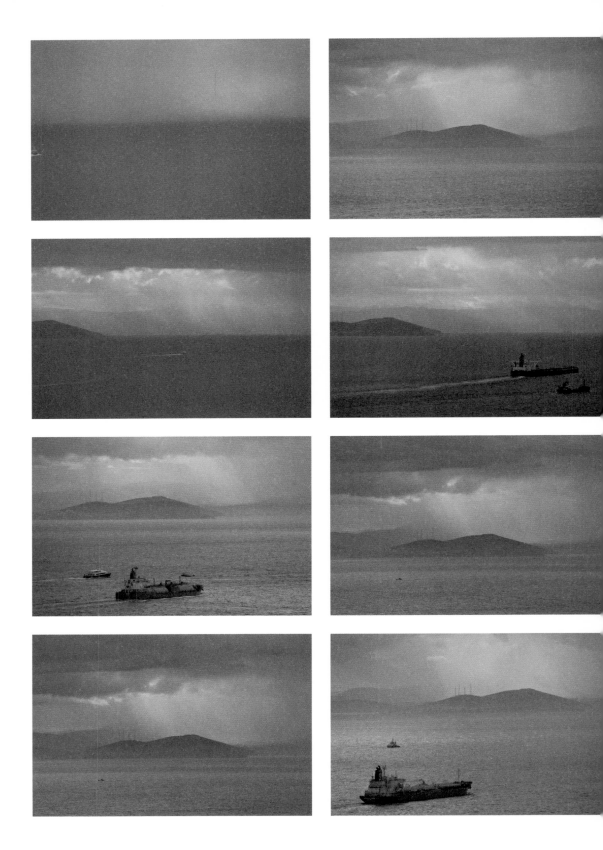

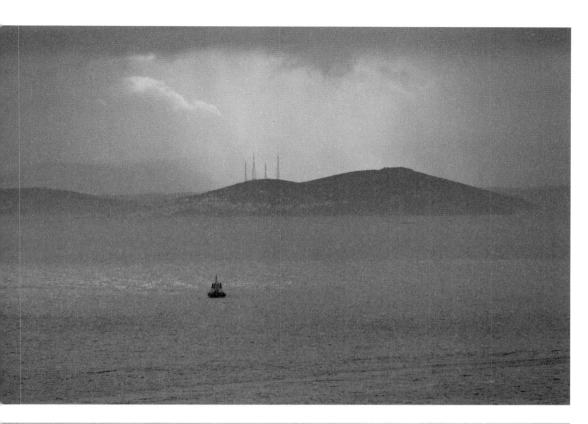

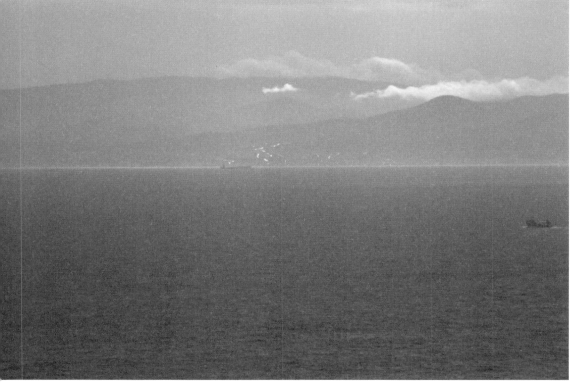

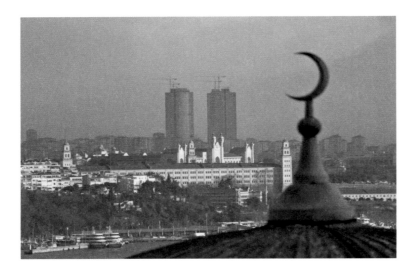

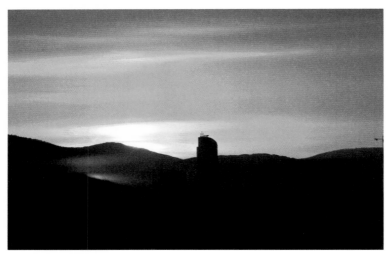

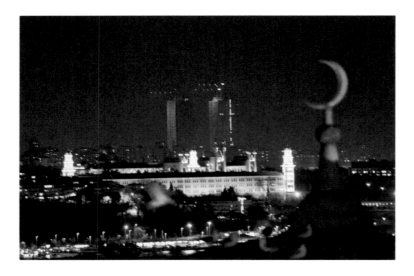

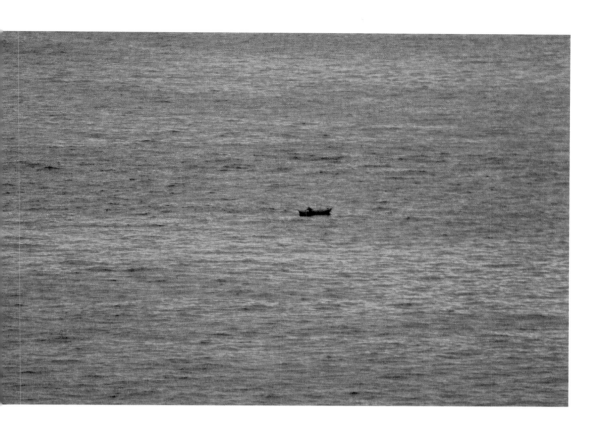

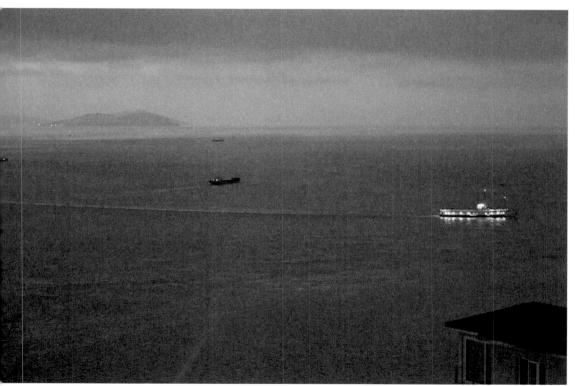

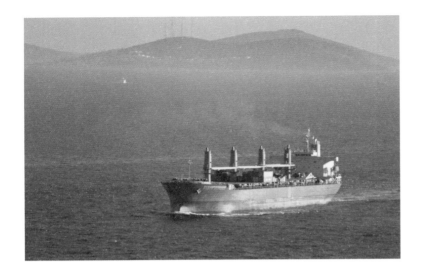

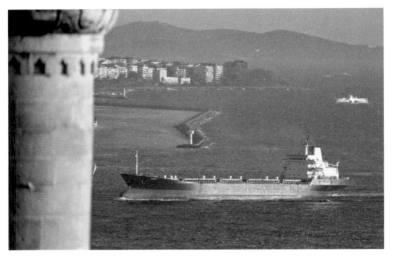

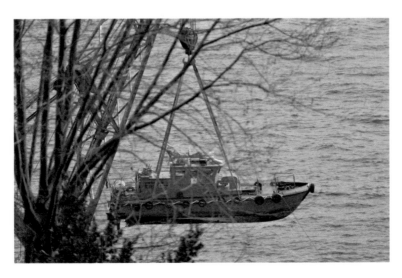

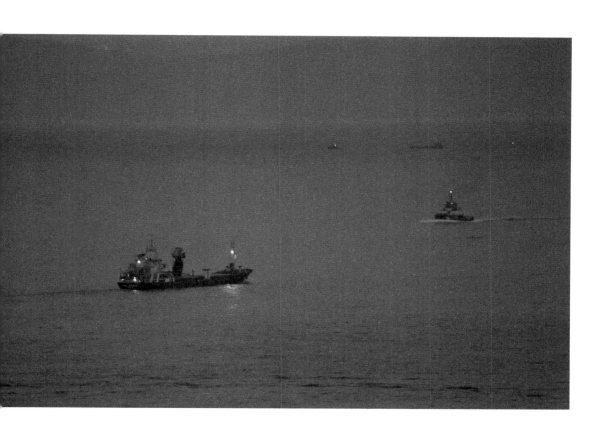

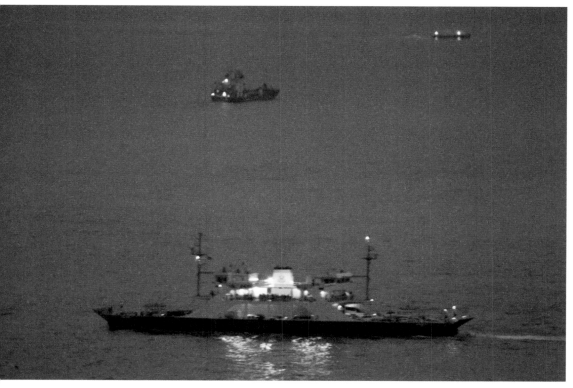

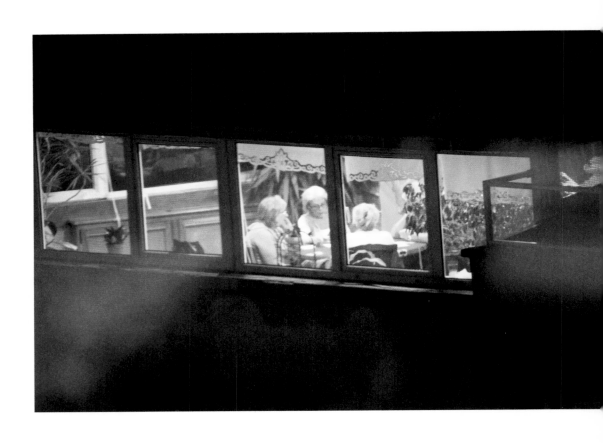

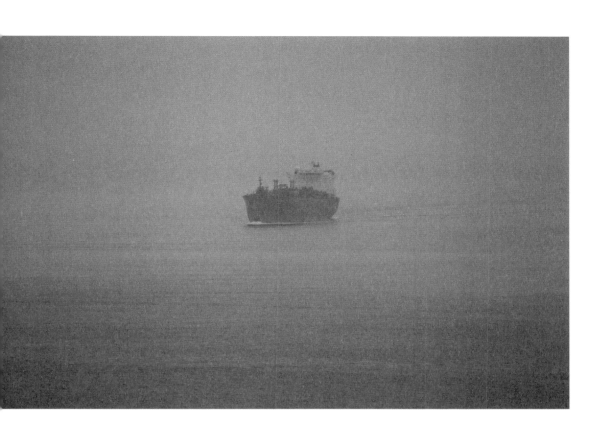

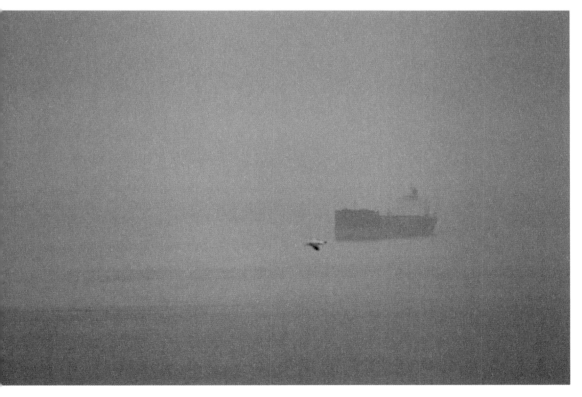

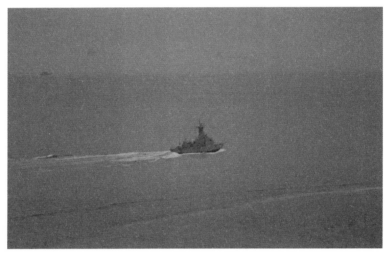

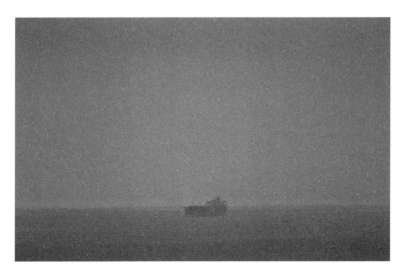

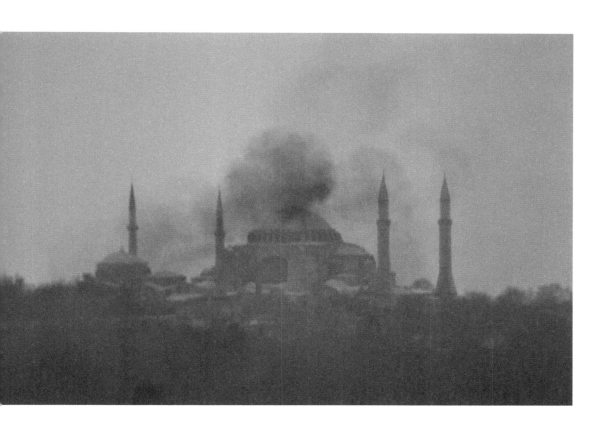

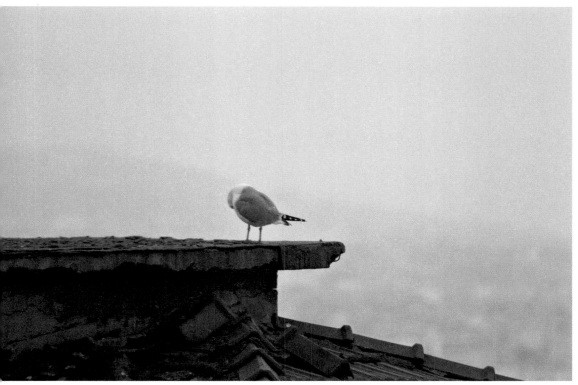

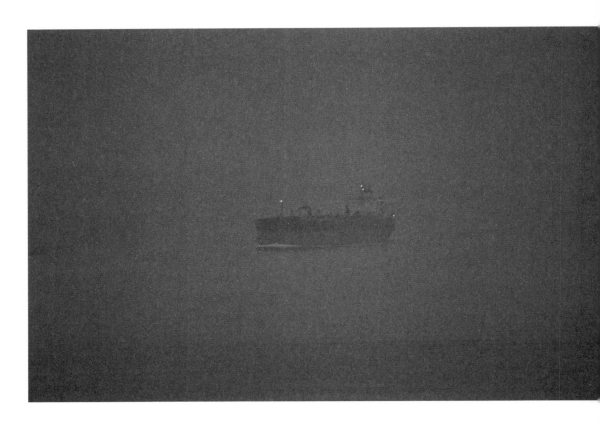

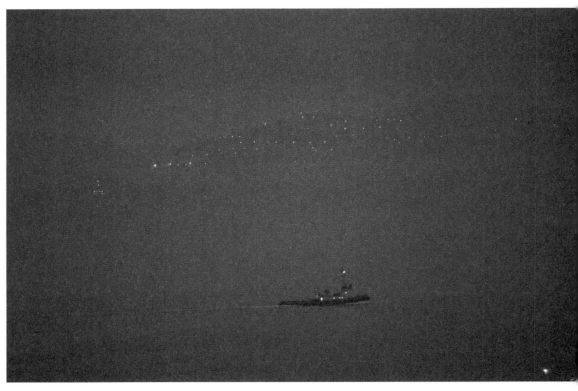

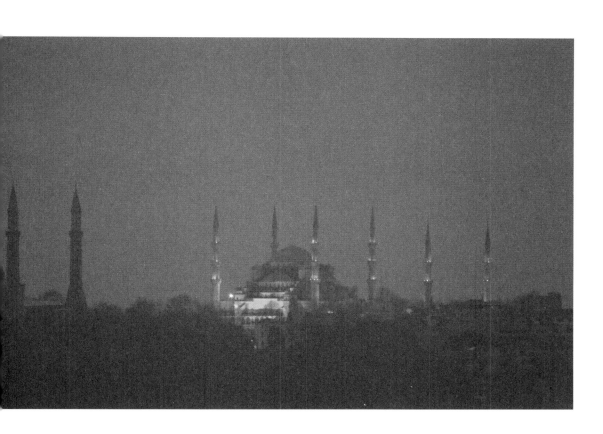

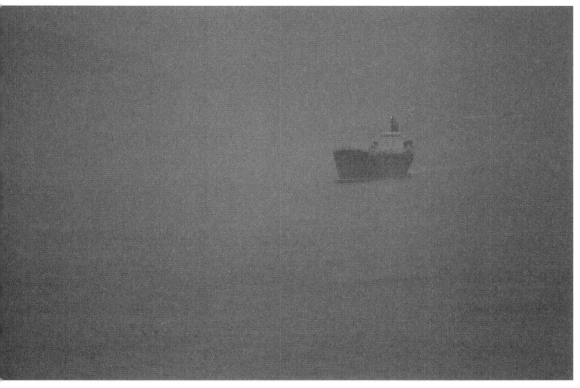

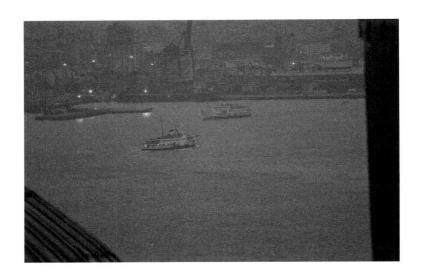

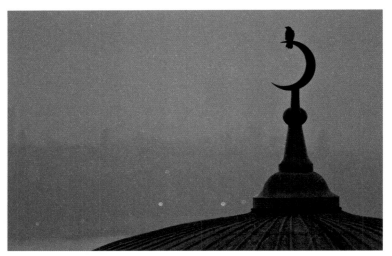

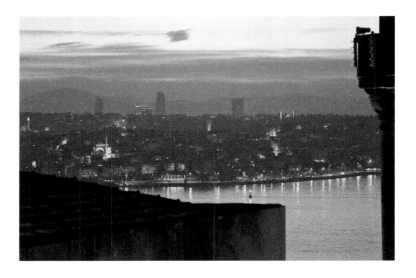

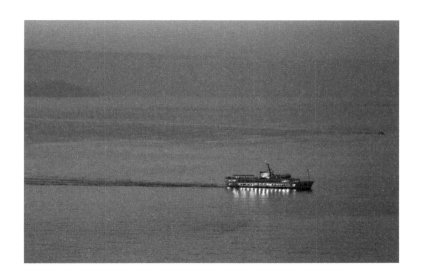

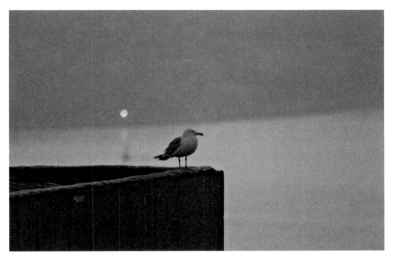

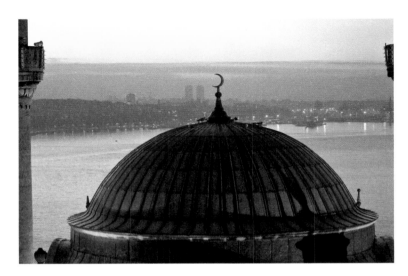

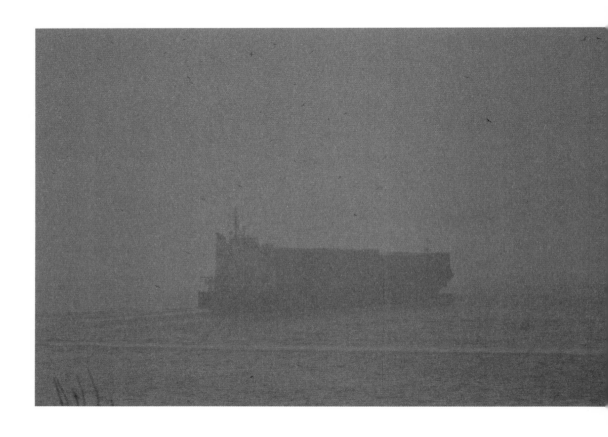

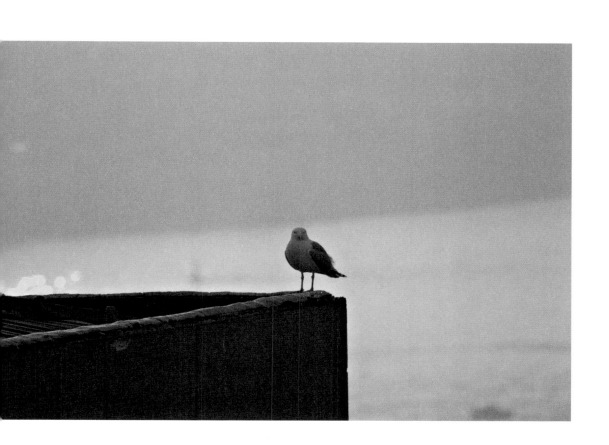

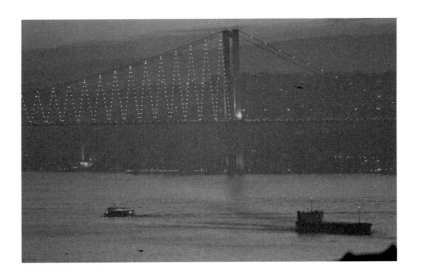

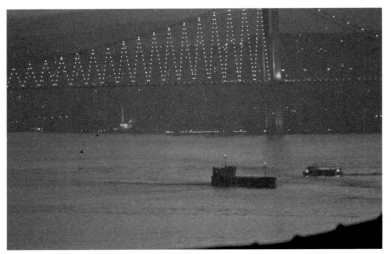

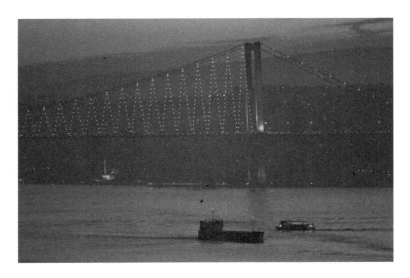

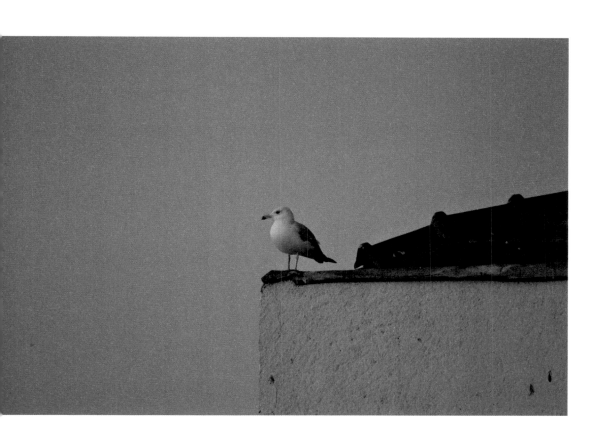

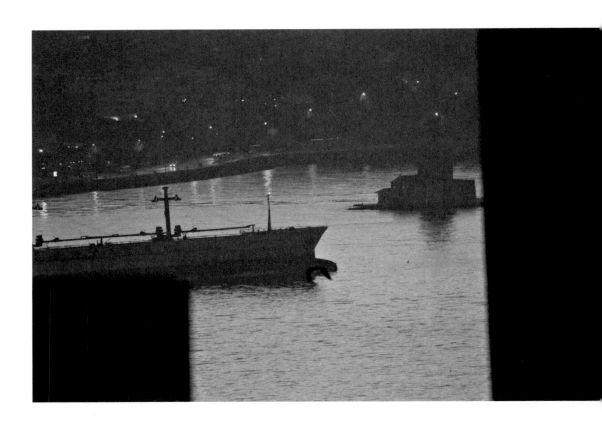

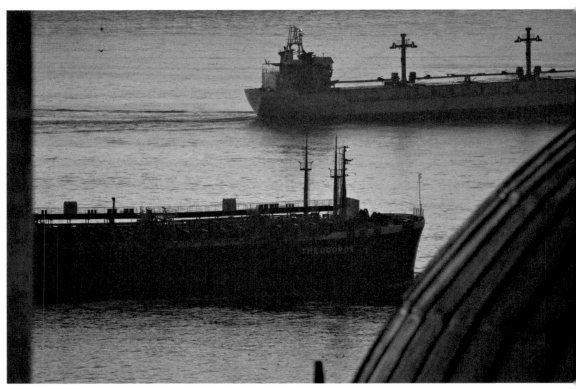

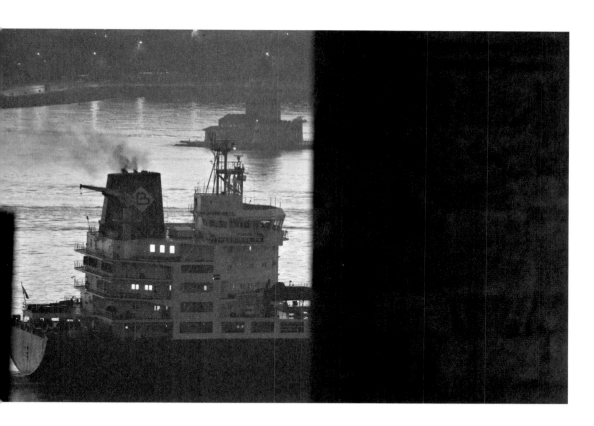

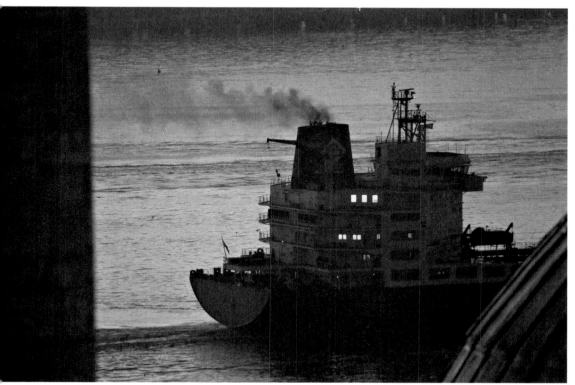

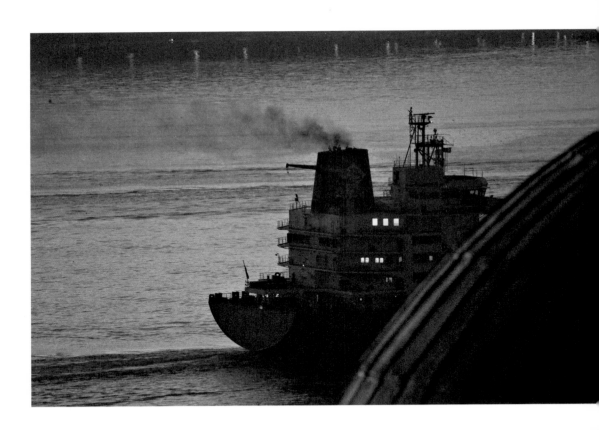

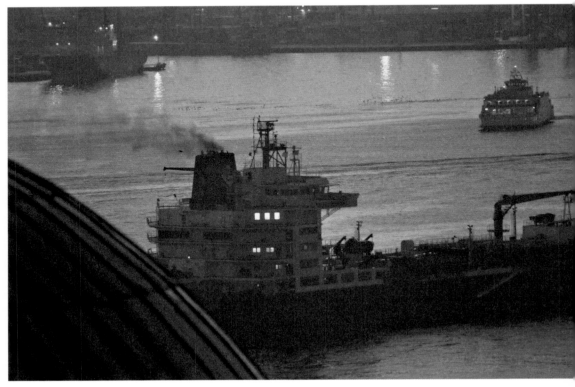

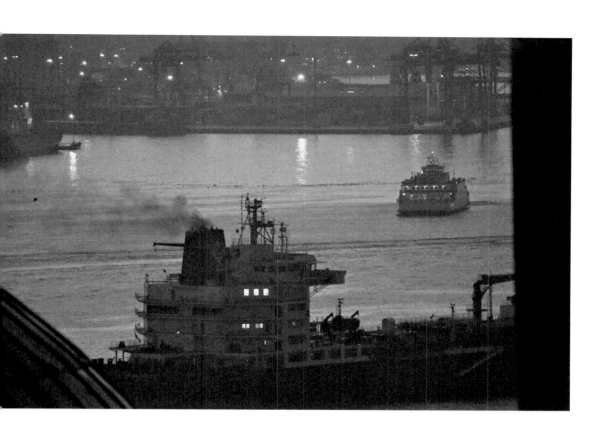

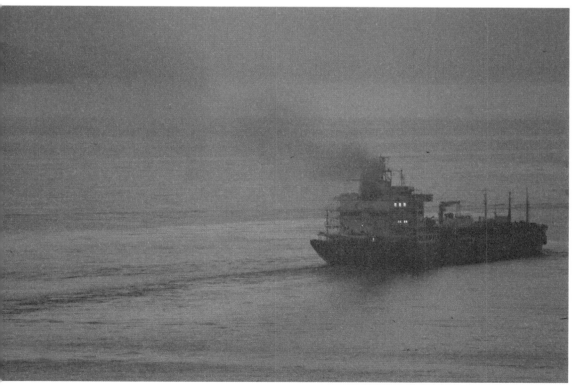

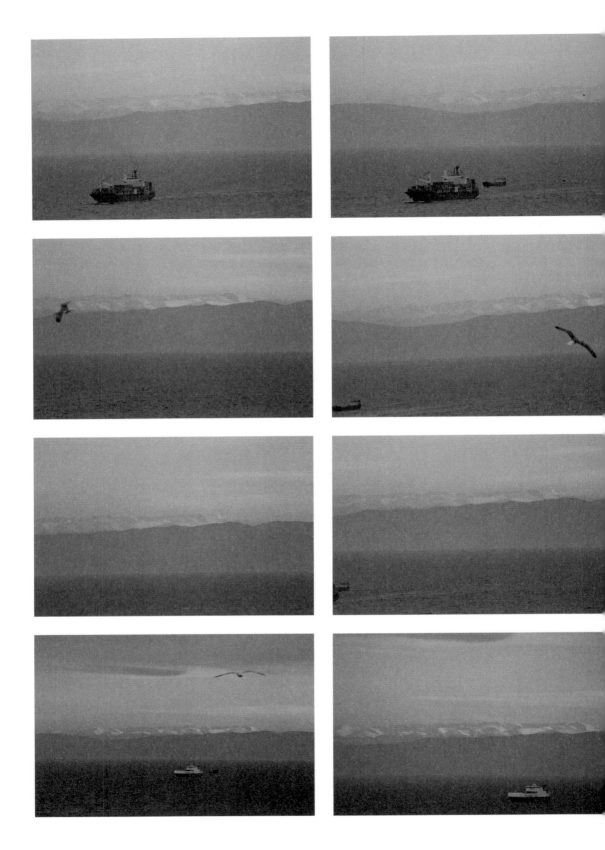

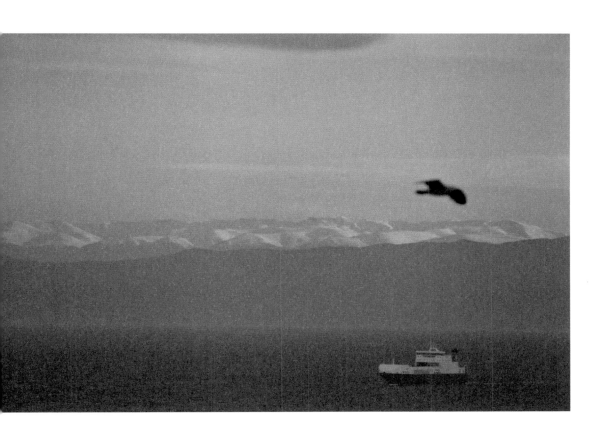

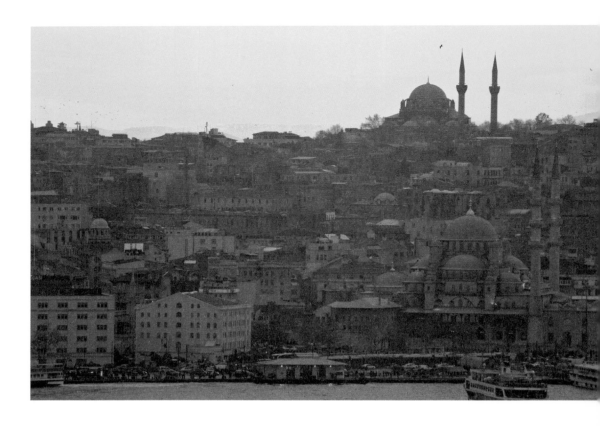

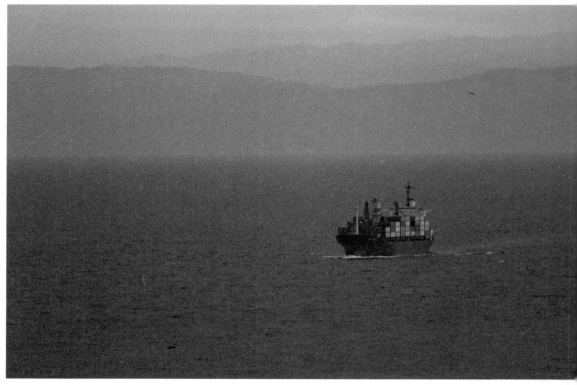

114

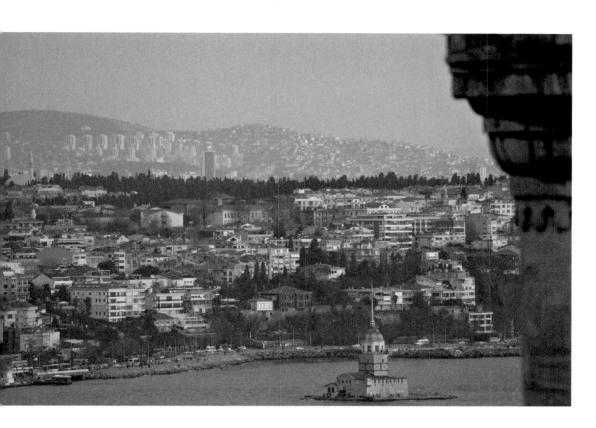

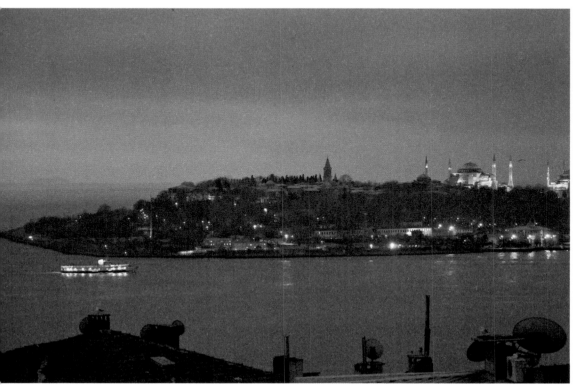

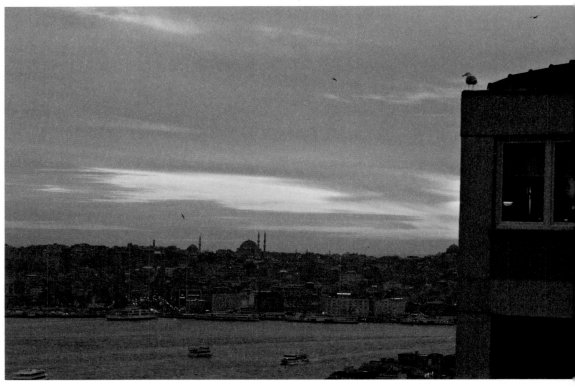

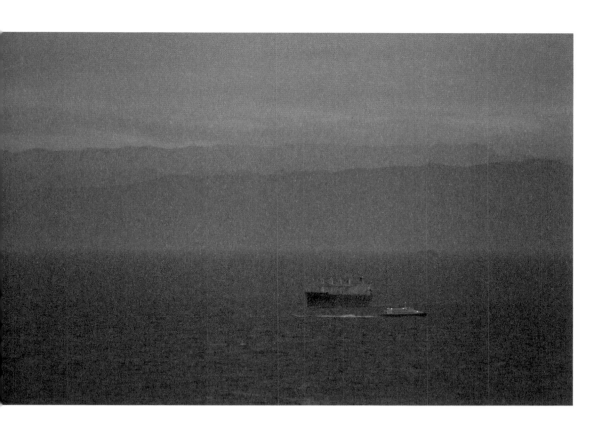

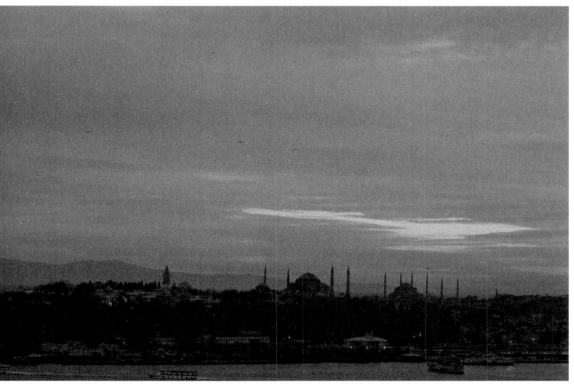

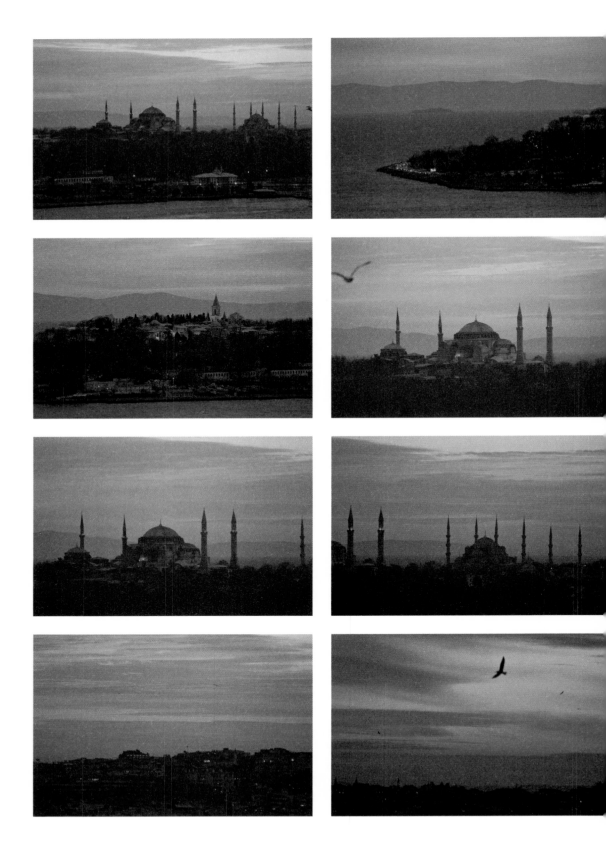

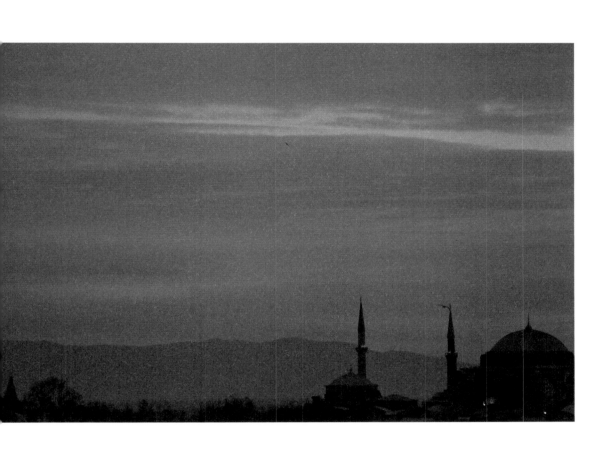

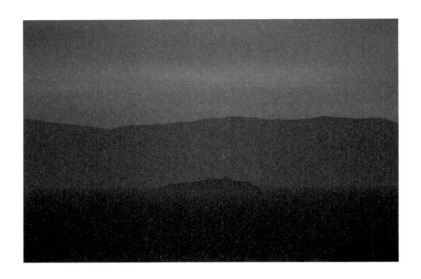

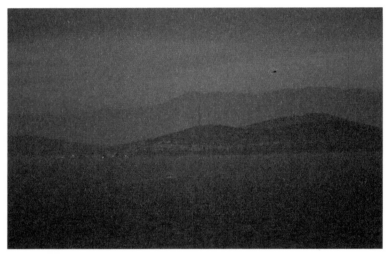

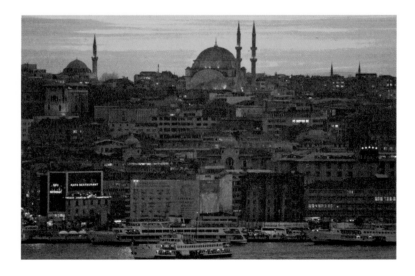

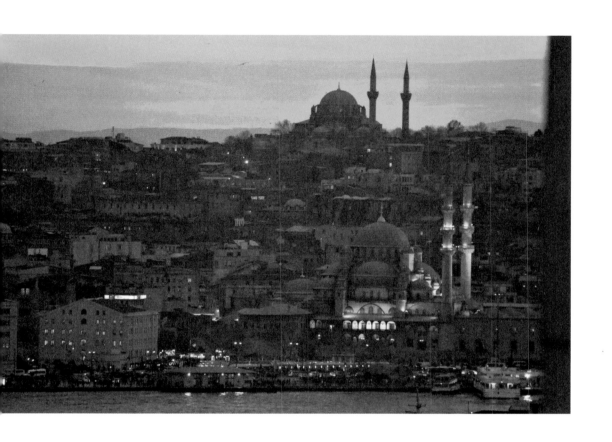

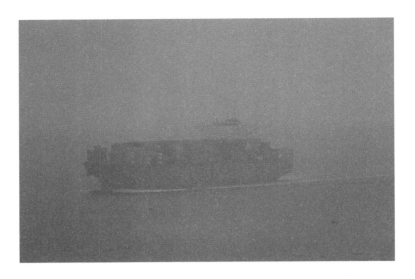

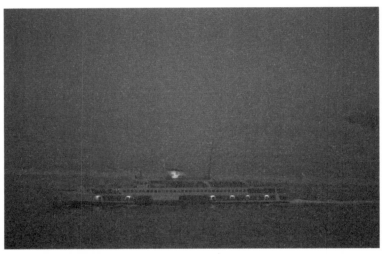

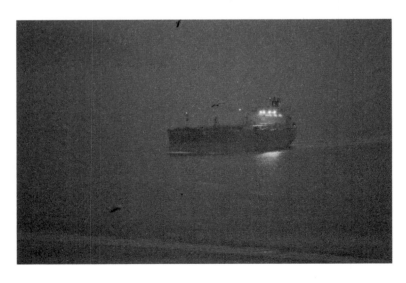

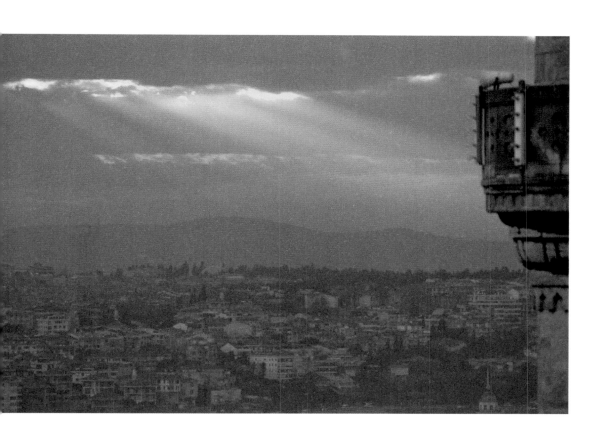

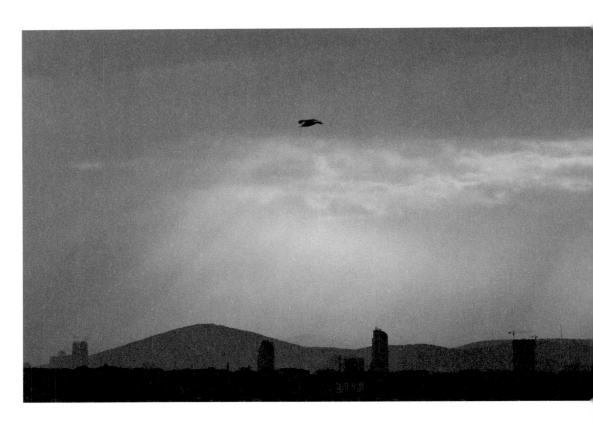

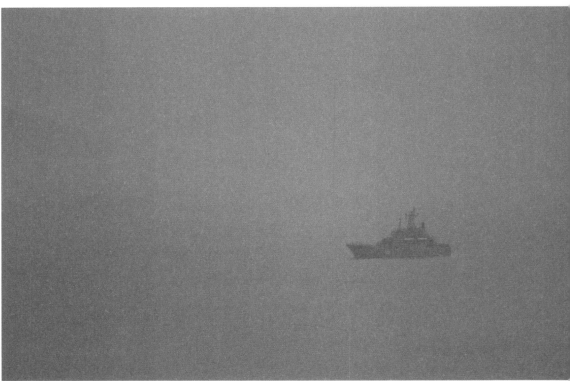

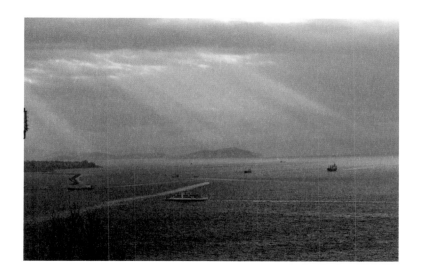

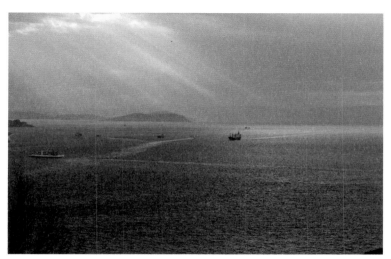

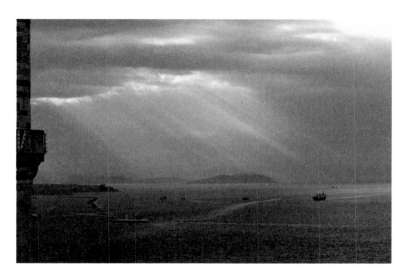

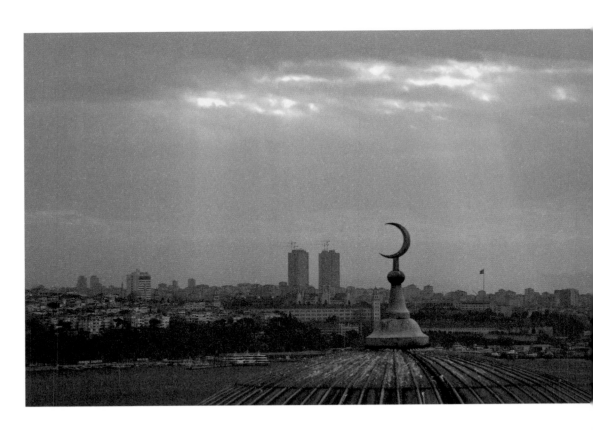

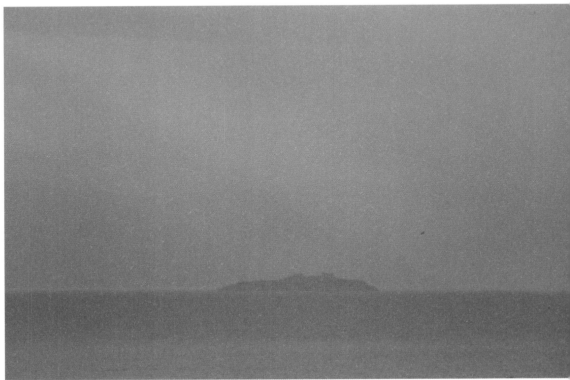

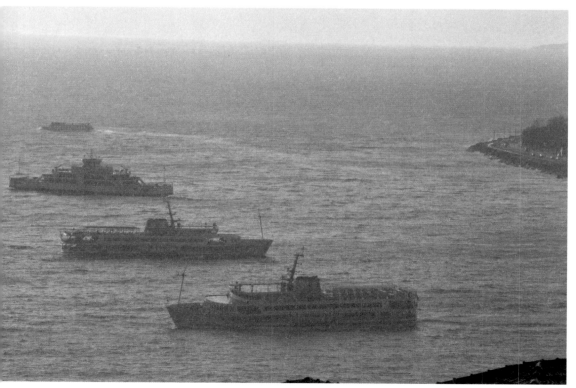

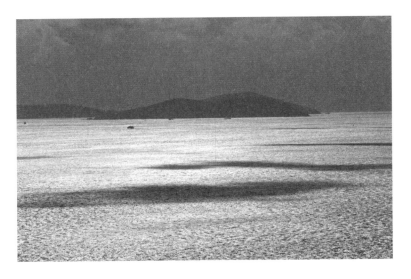

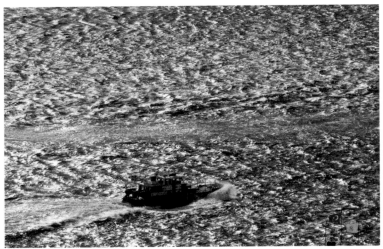

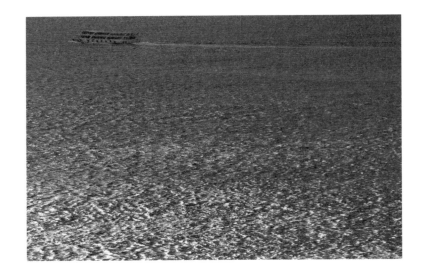

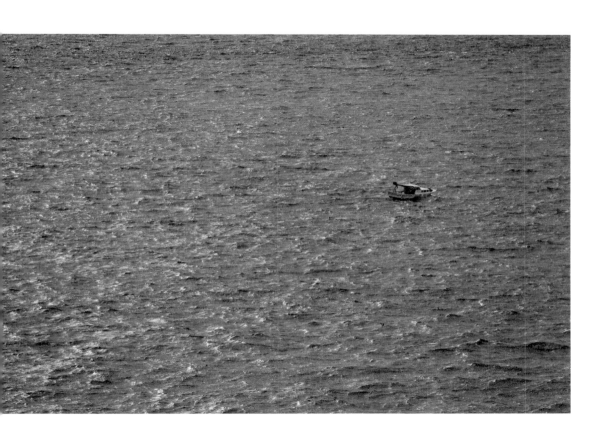

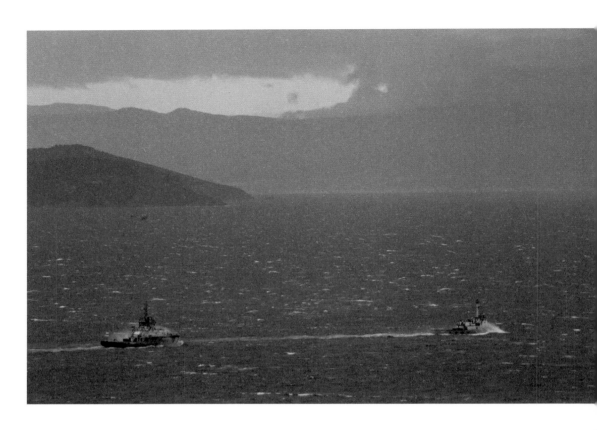

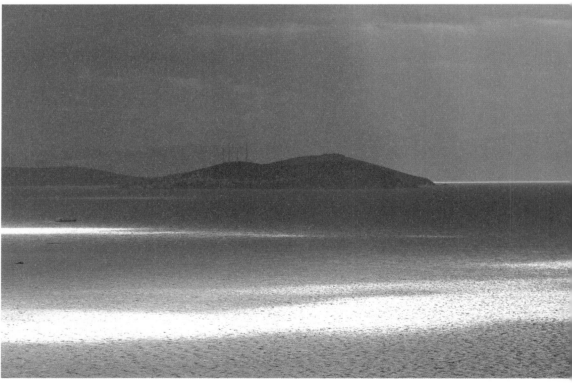

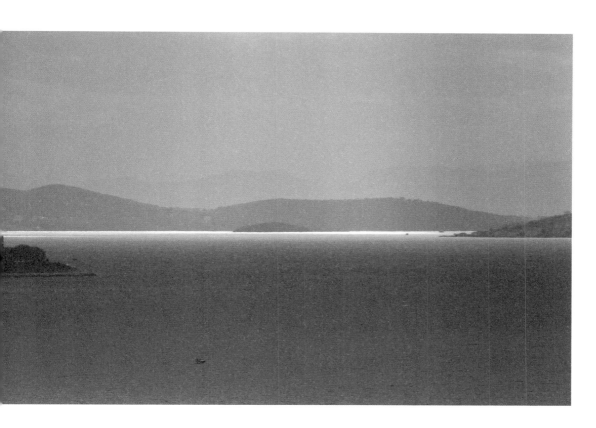

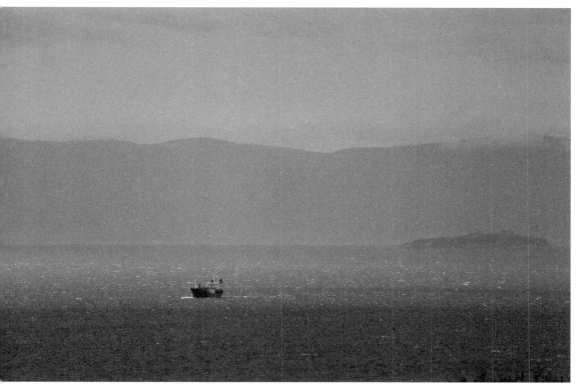

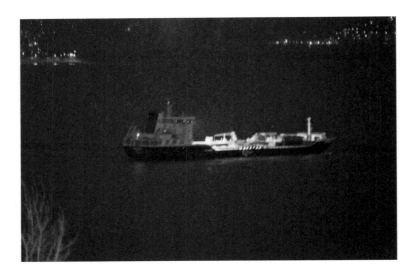

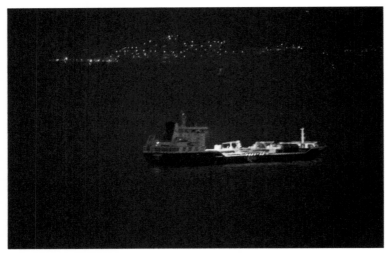

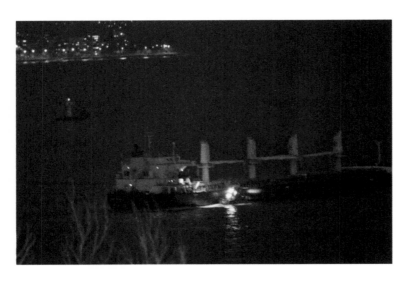

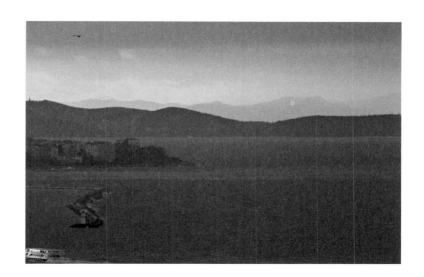

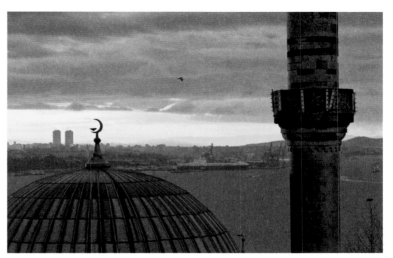

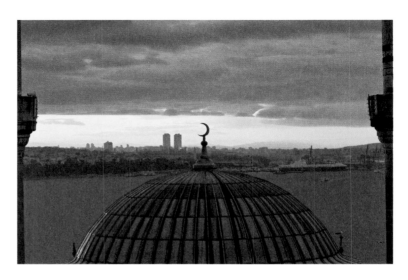

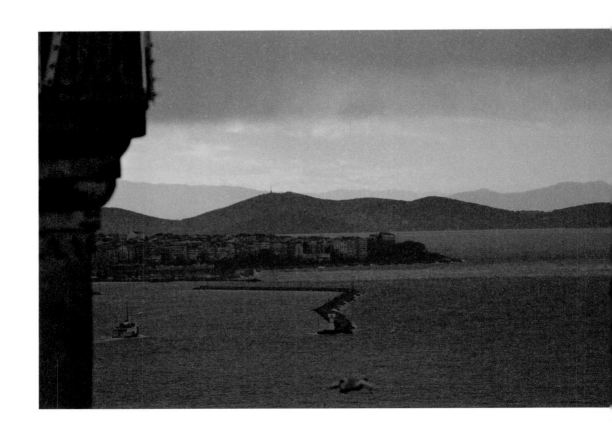

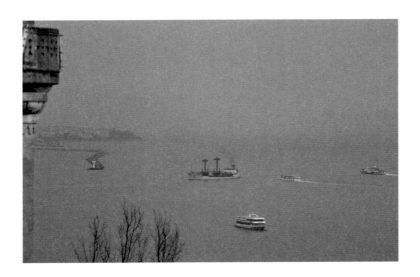

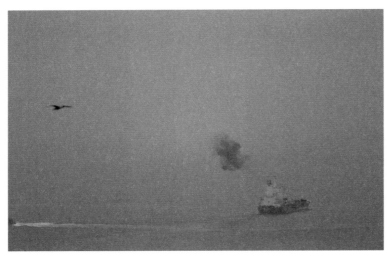

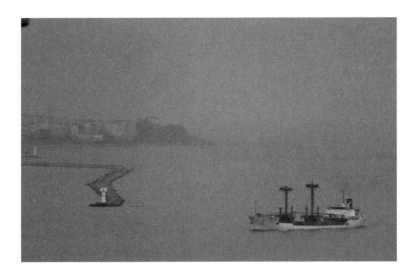

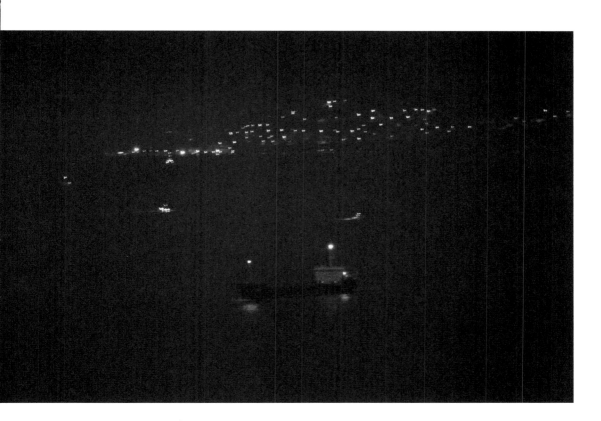

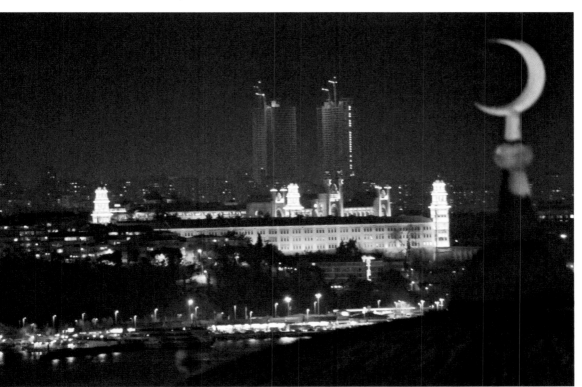

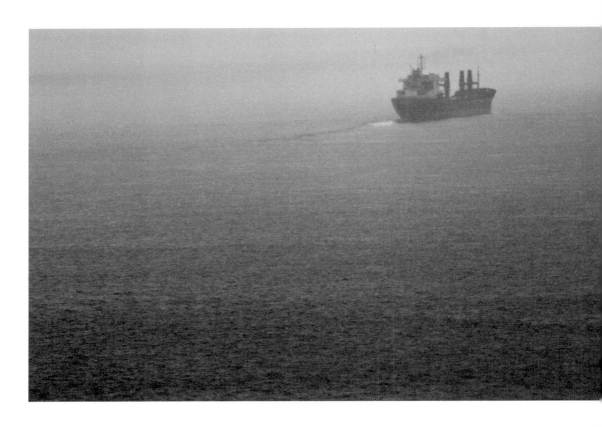

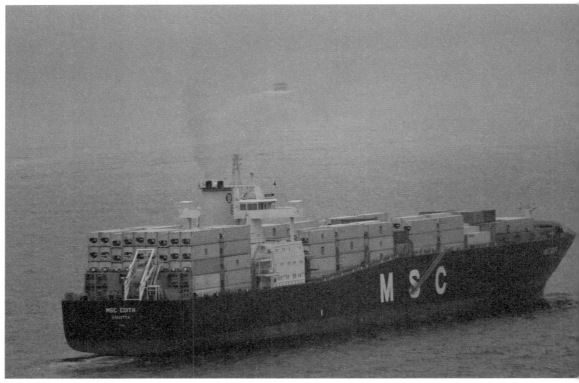

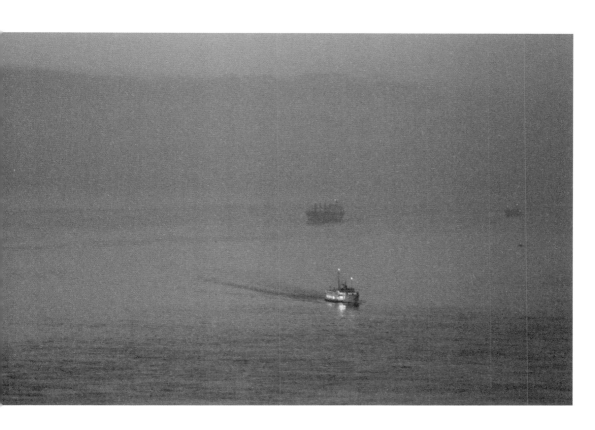

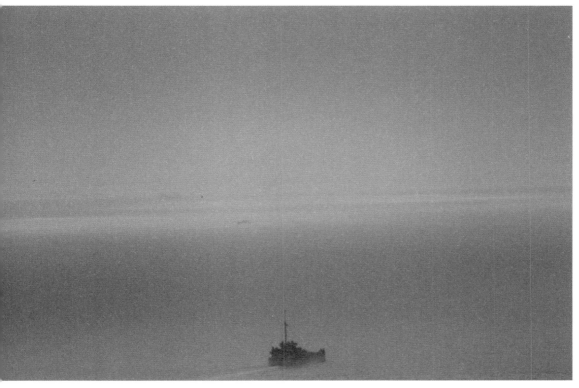

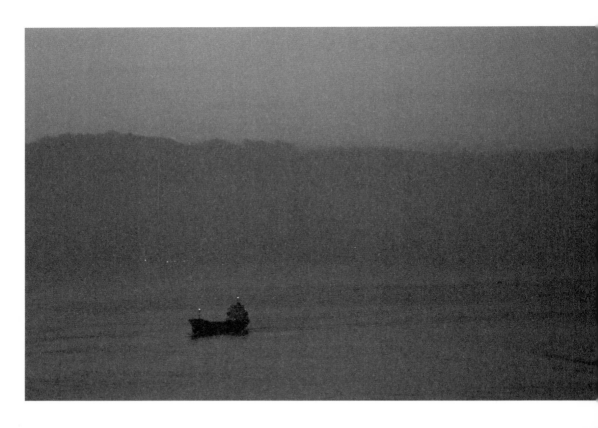

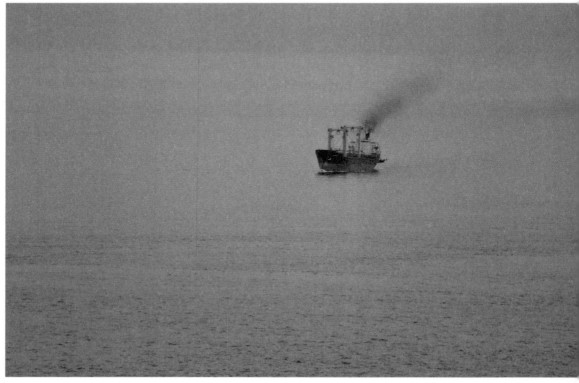

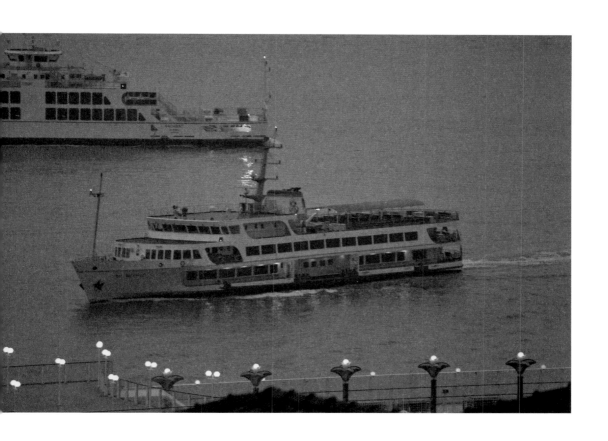

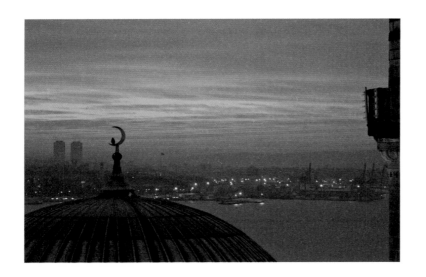

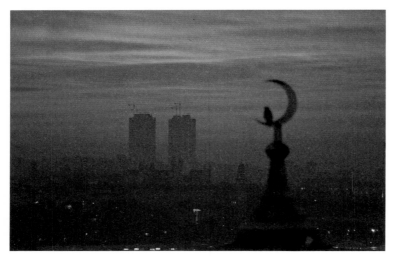

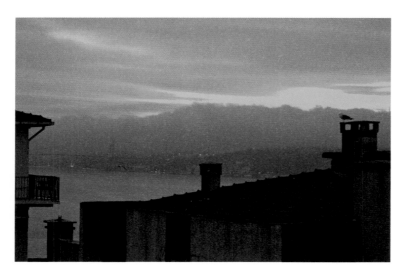

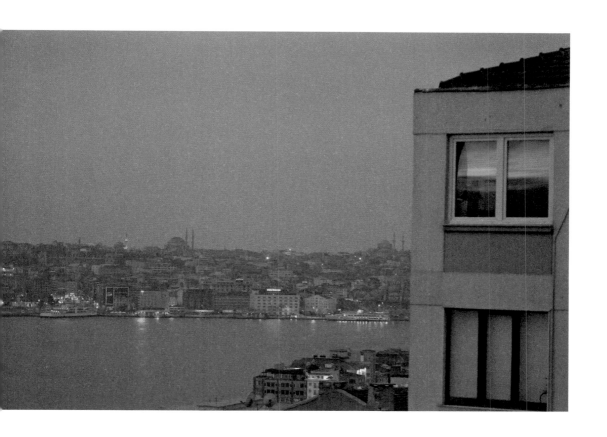

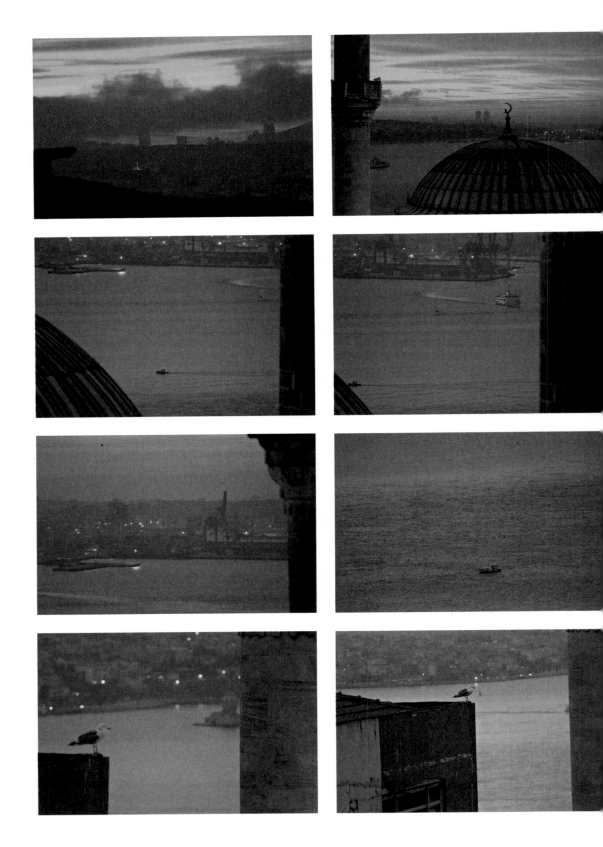

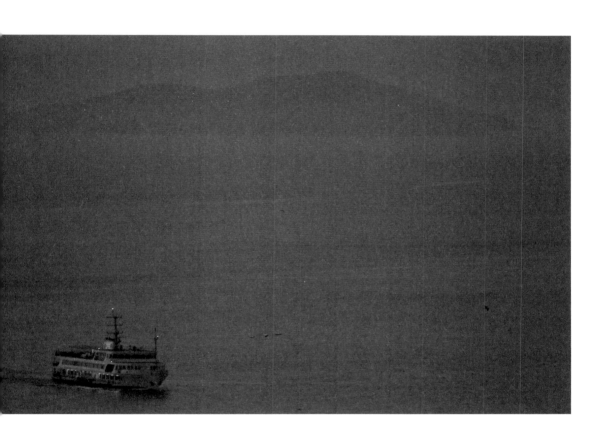

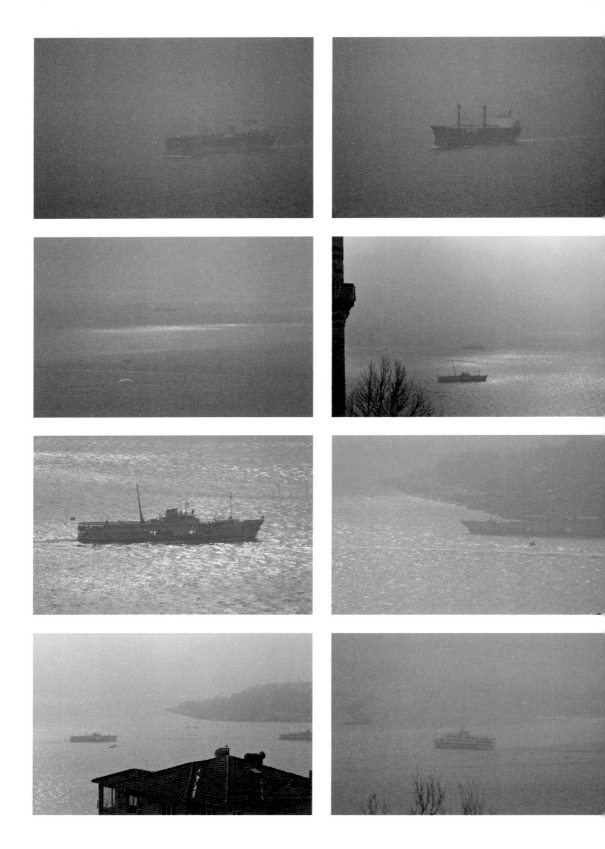

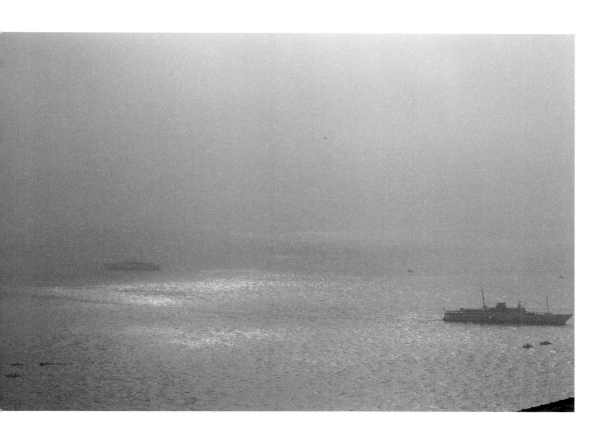

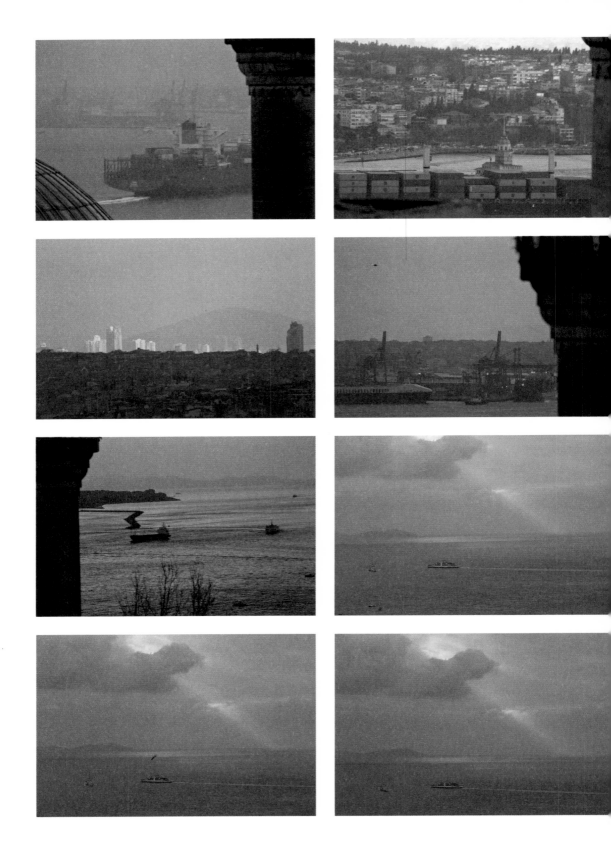

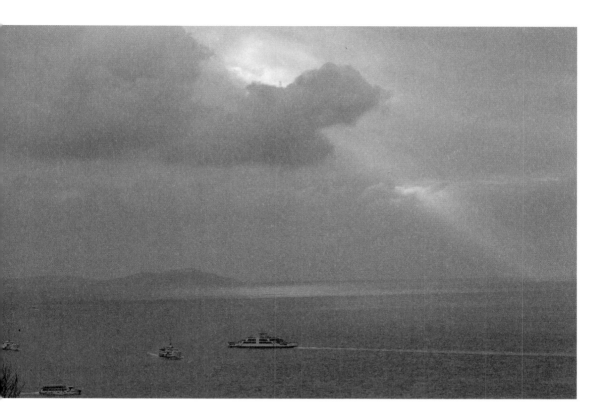

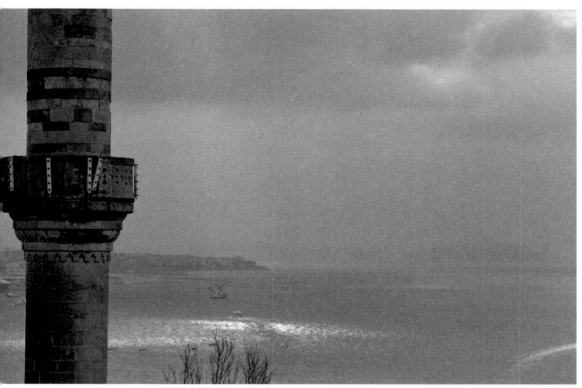

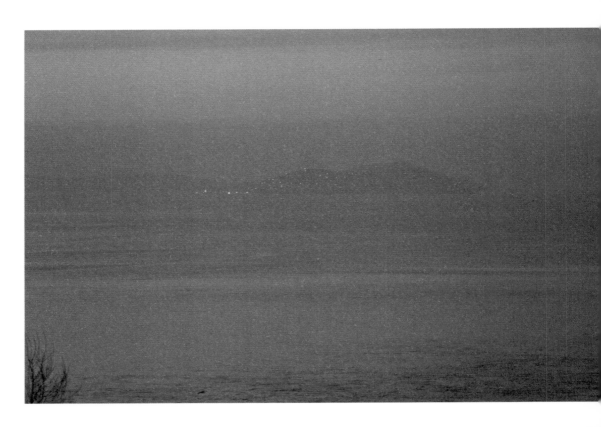

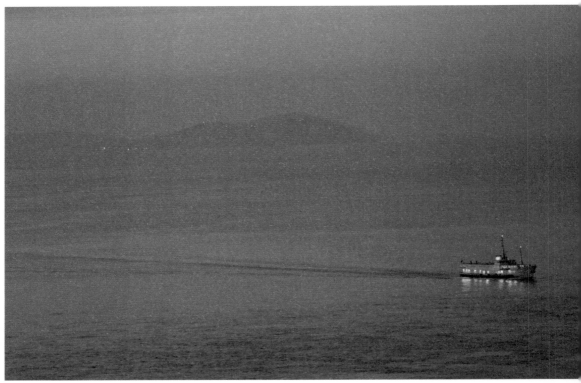

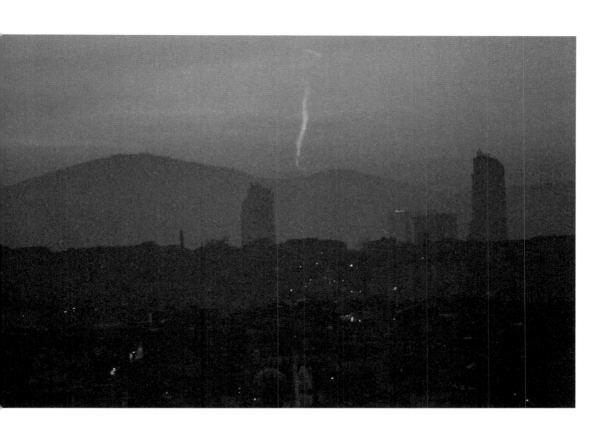

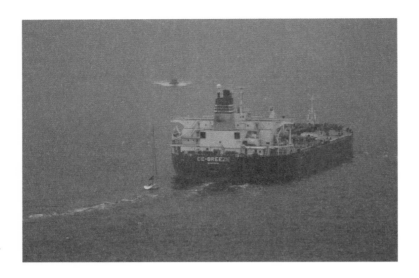

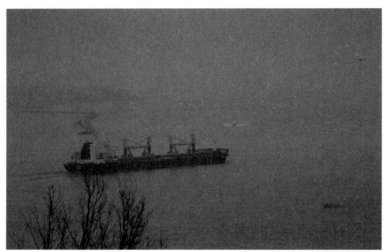

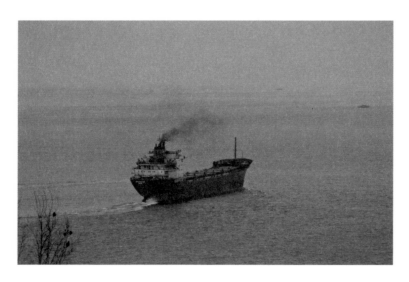

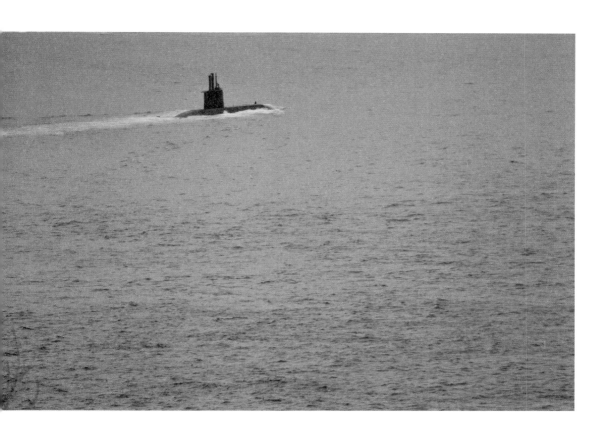

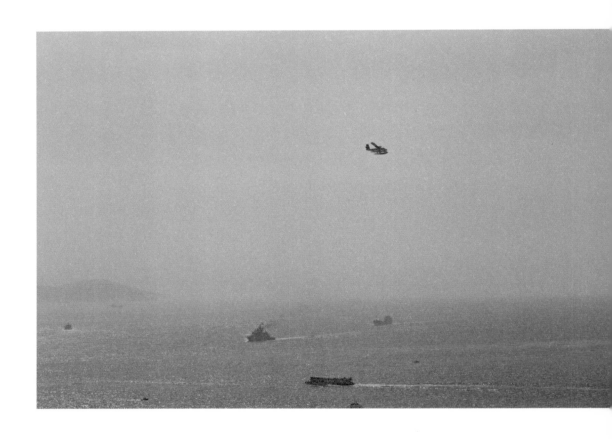

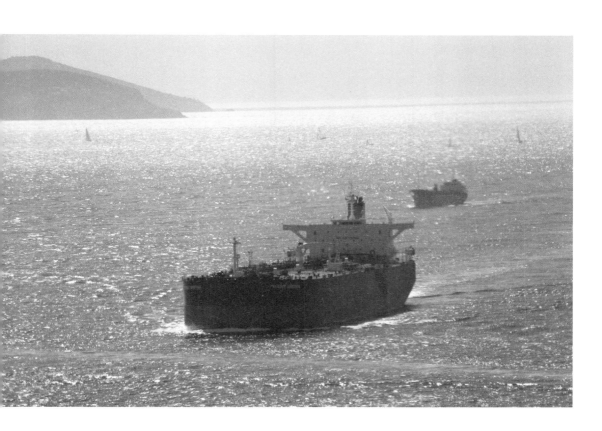

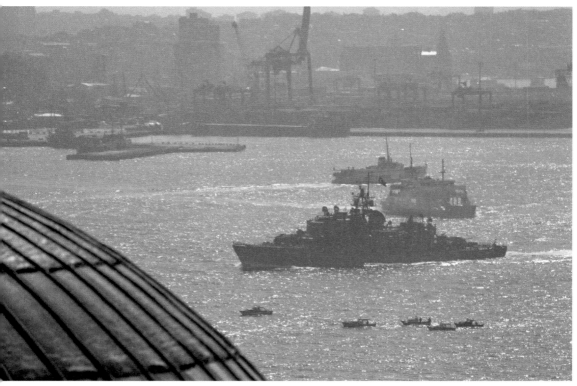

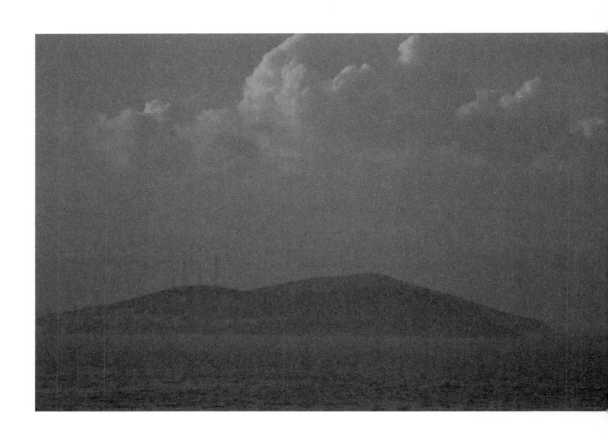

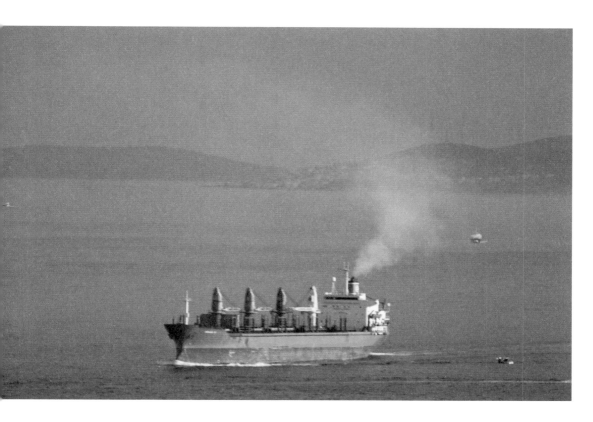

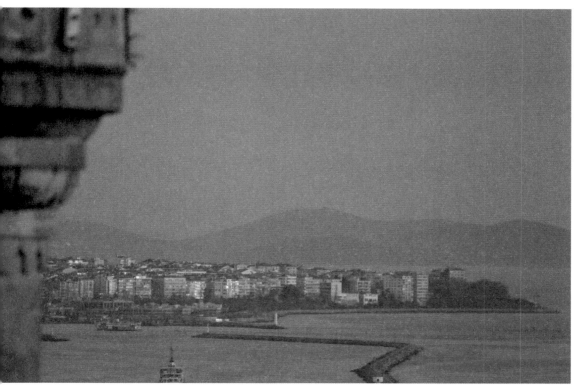

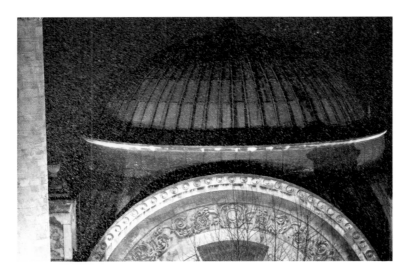

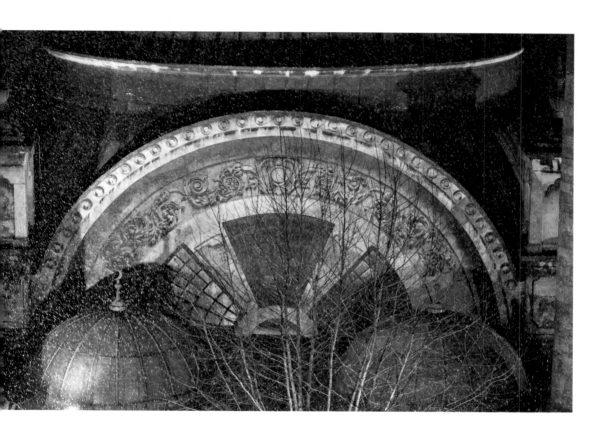

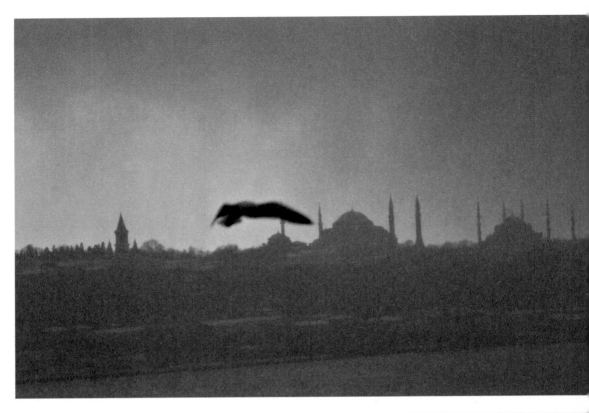

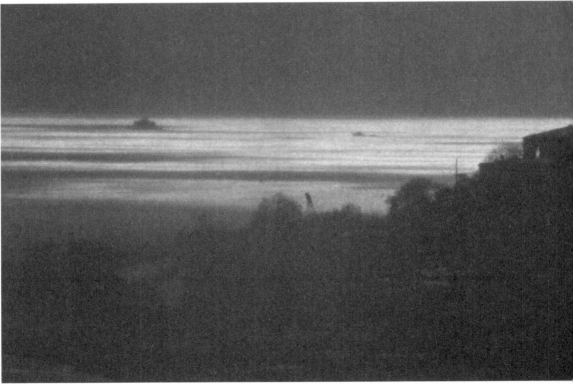

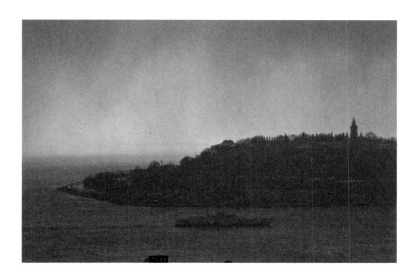

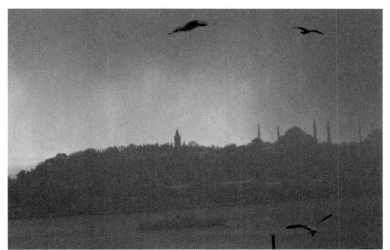

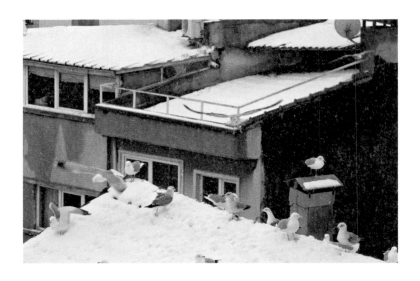

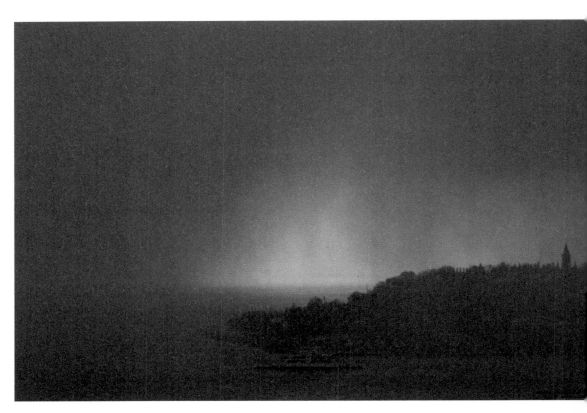

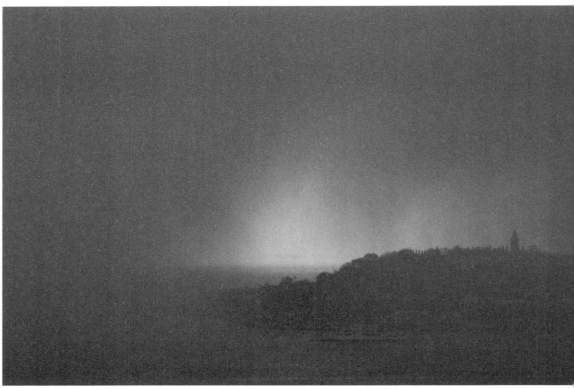

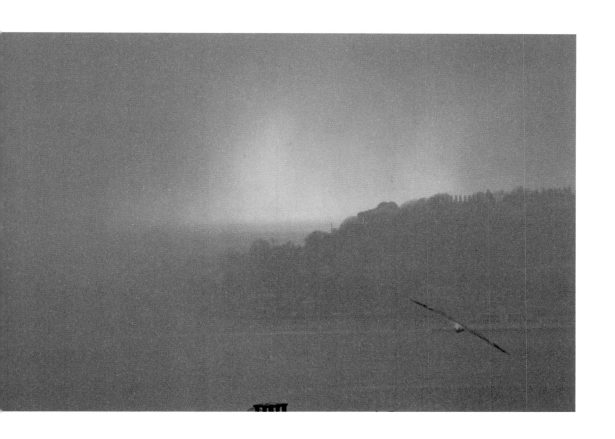

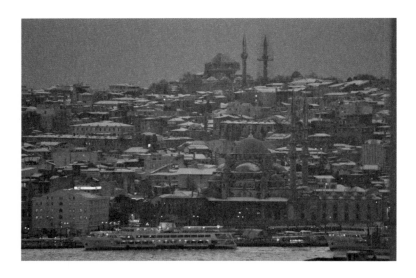

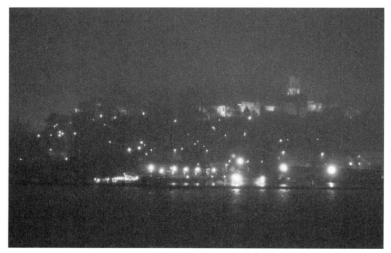

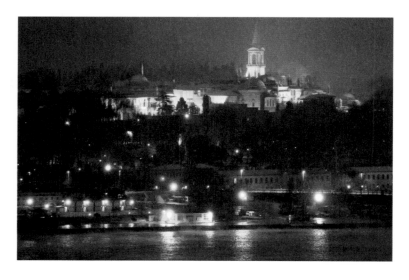

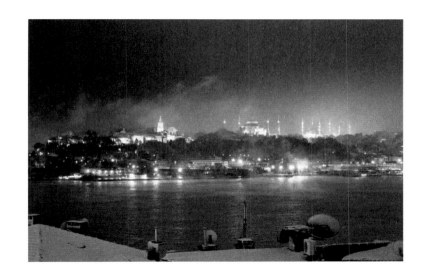

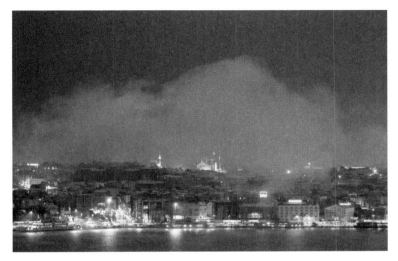

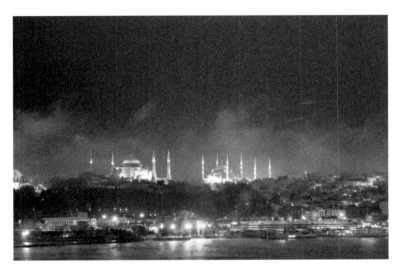

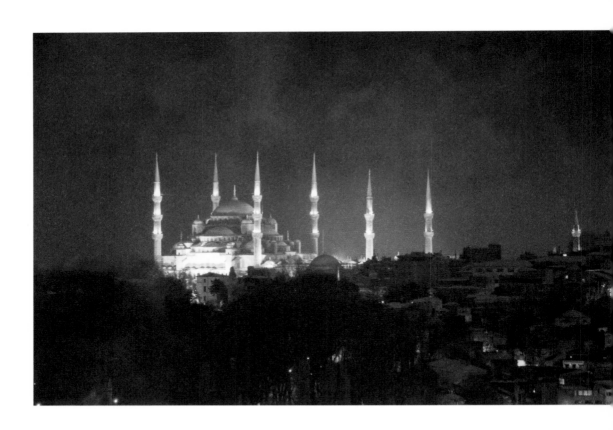

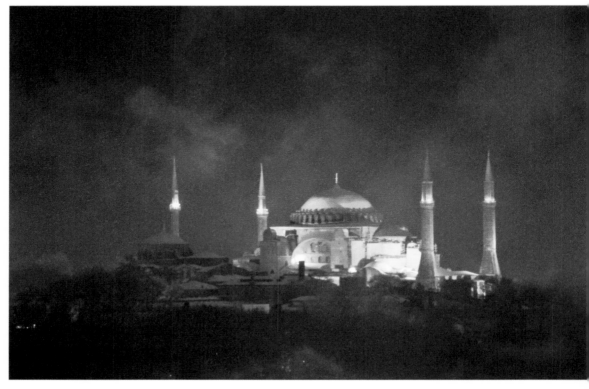

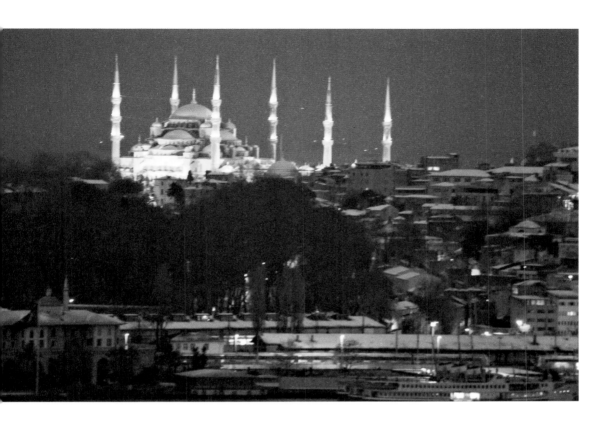

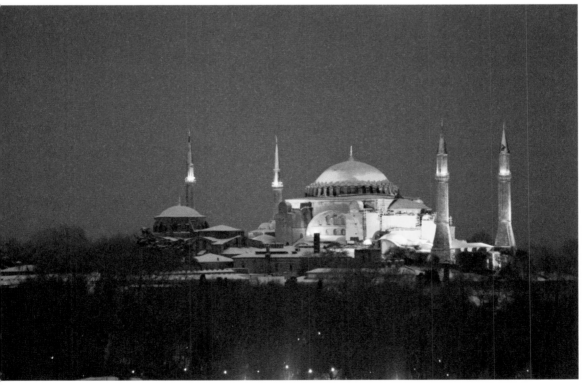

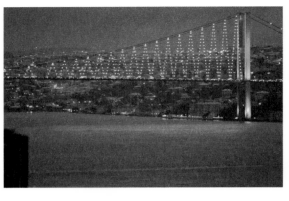
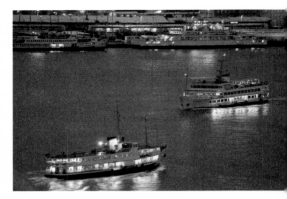
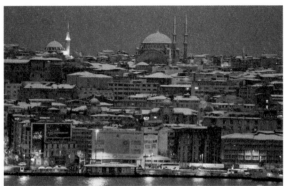
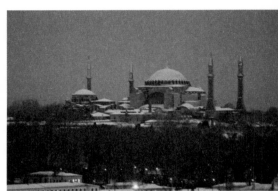
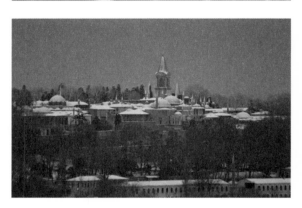
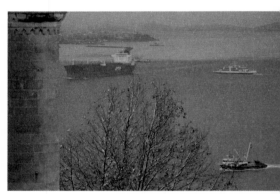
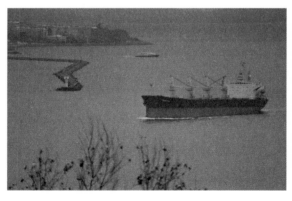

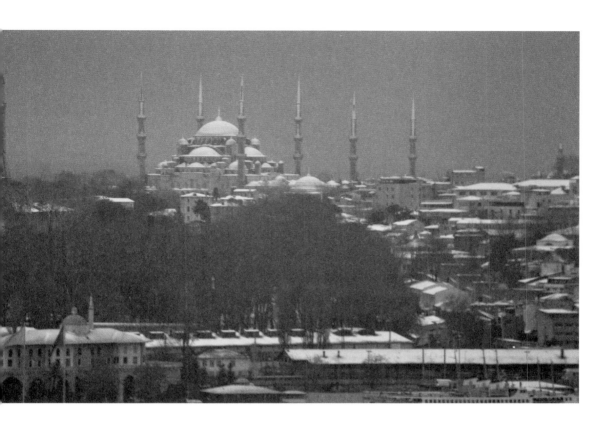

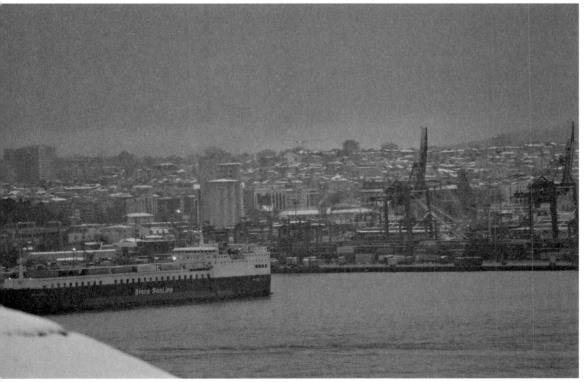

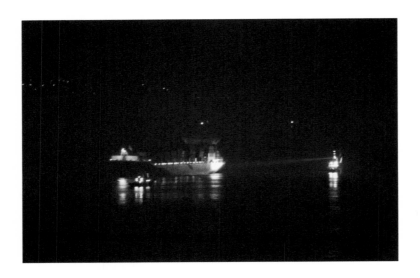

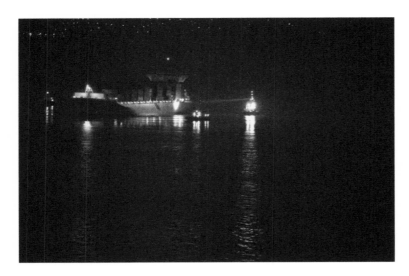

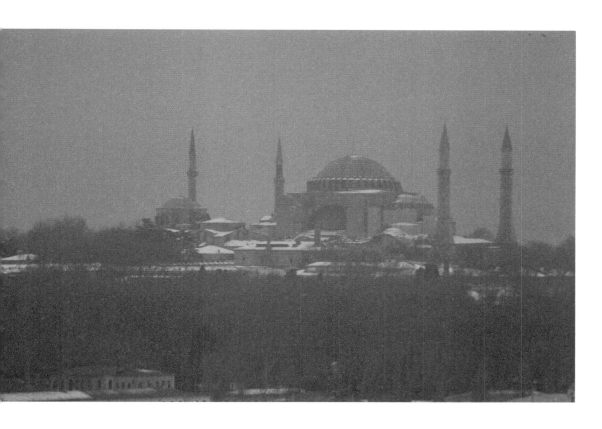

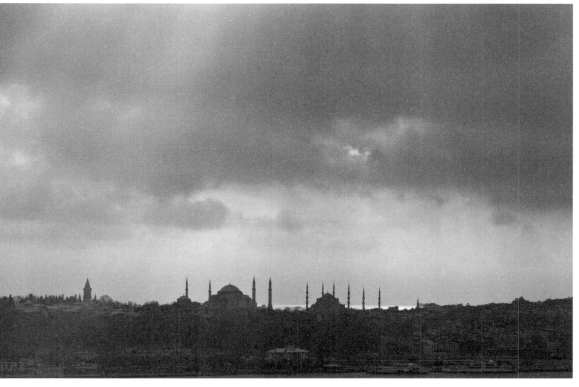

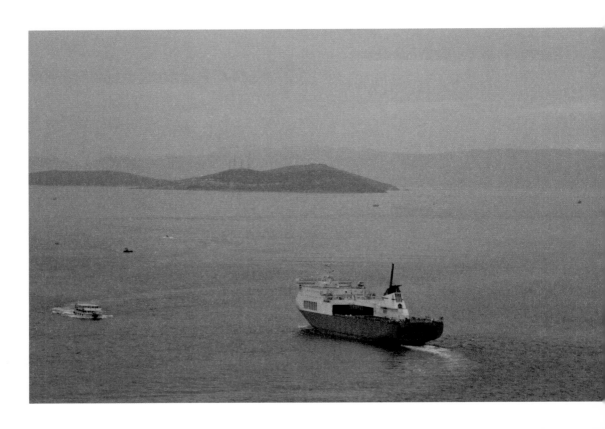

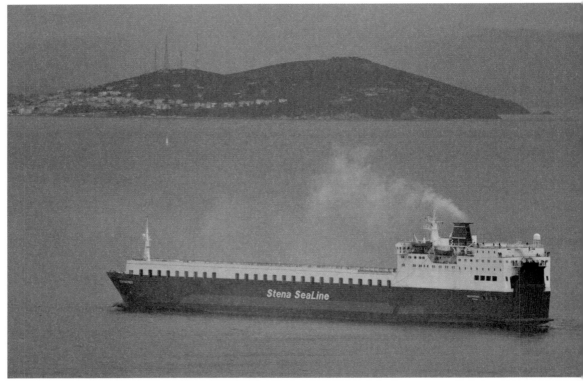

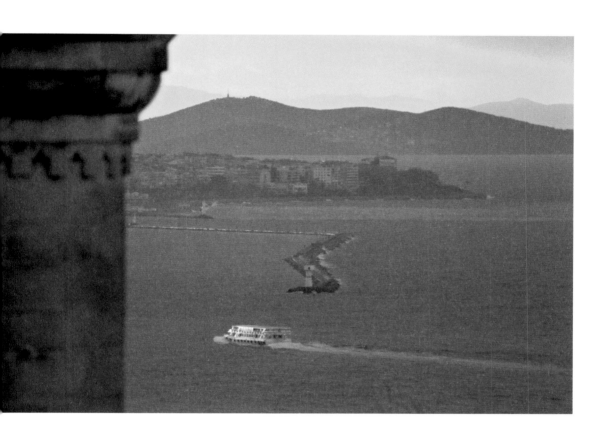

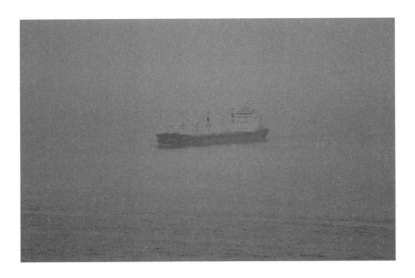

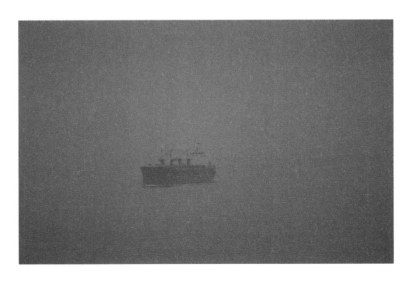

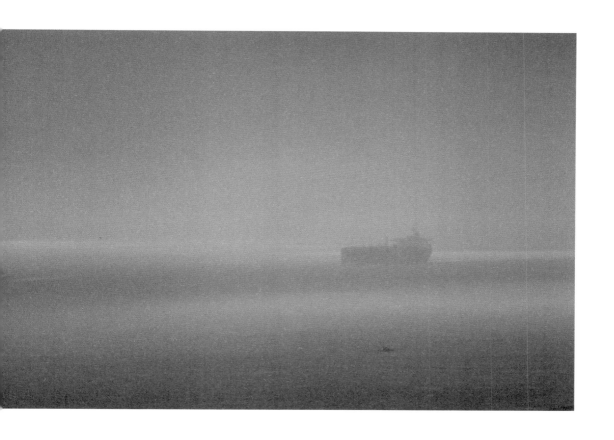

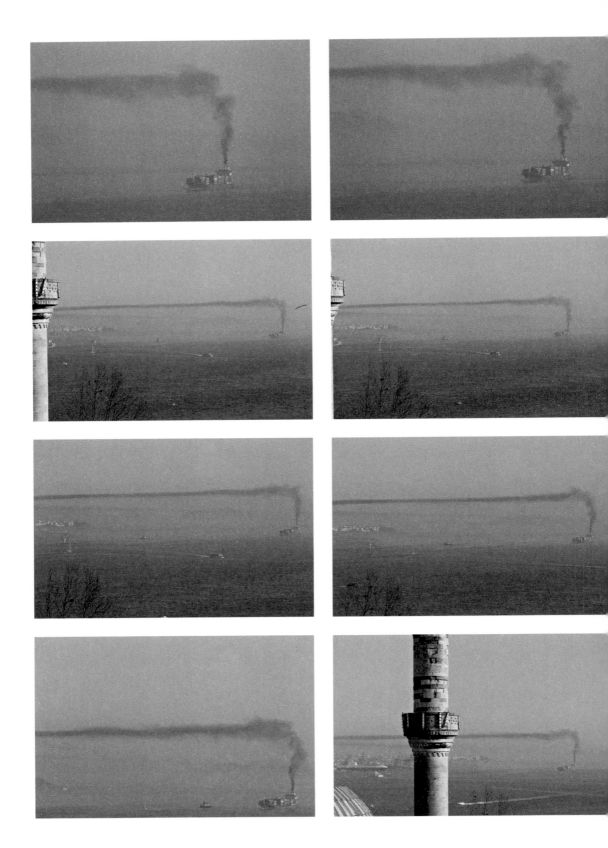

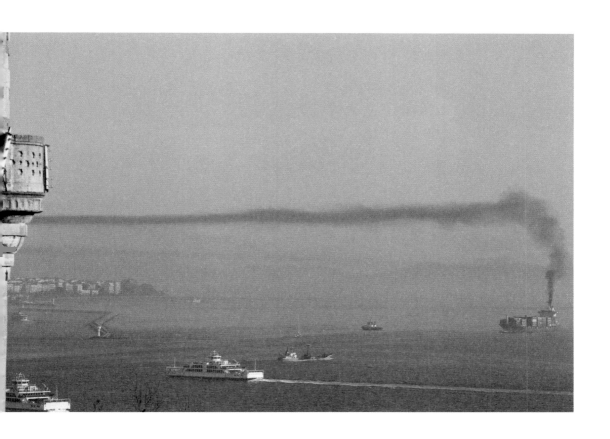

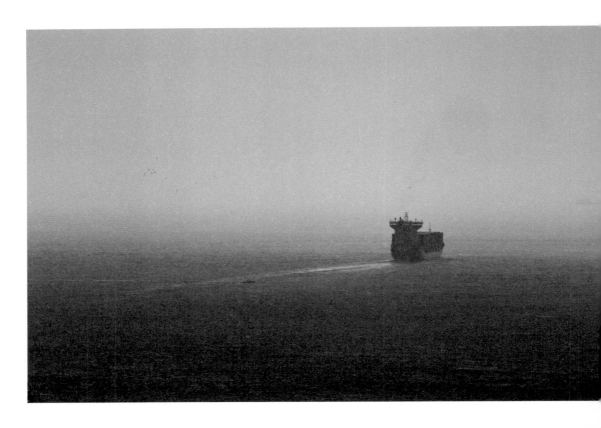

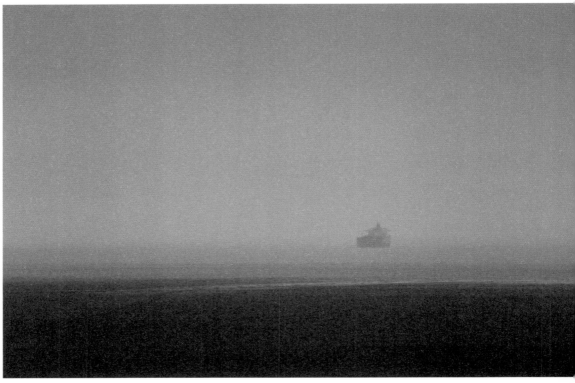

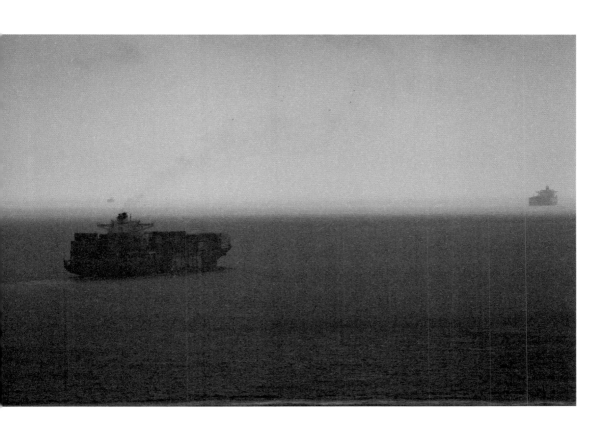

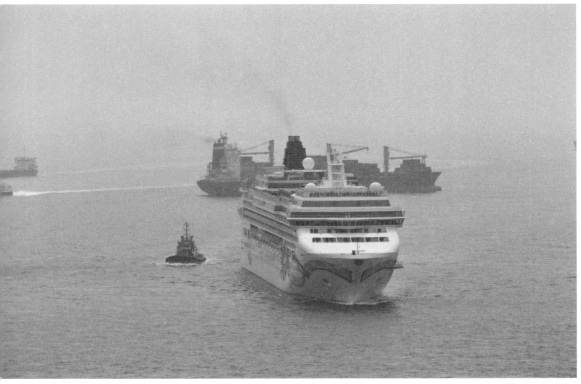

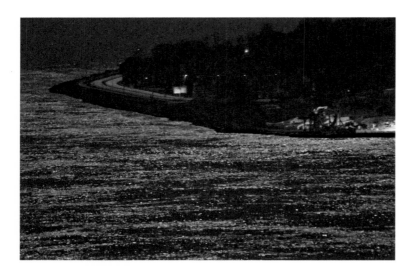

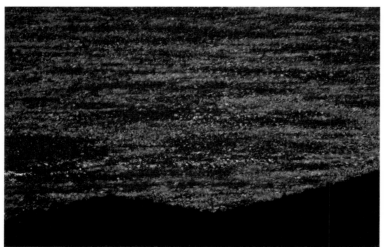

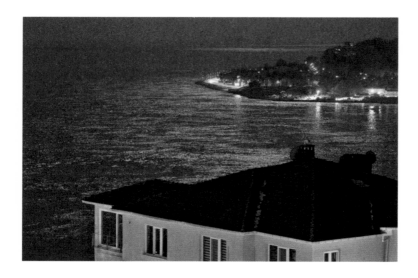

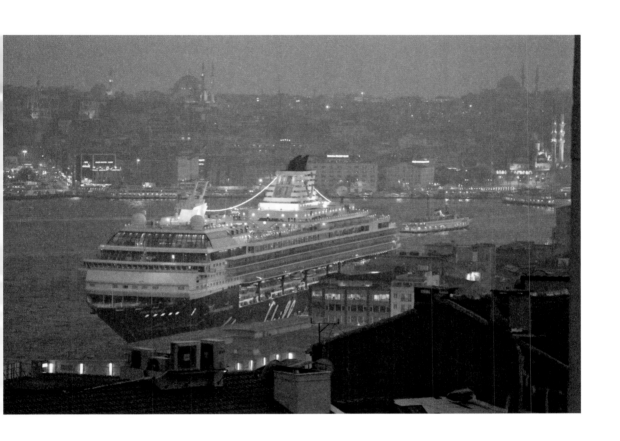

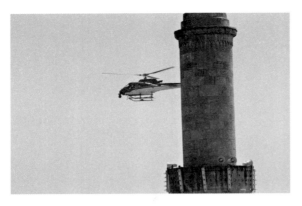
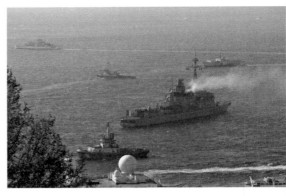
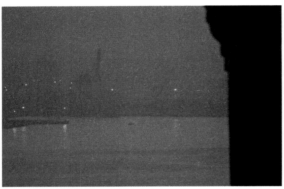
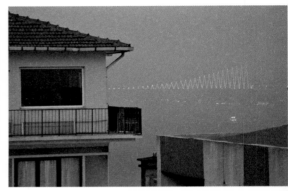
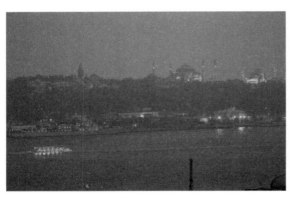
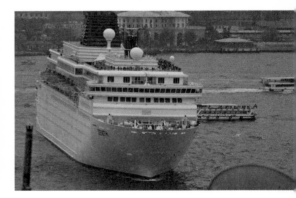
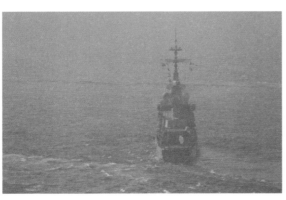

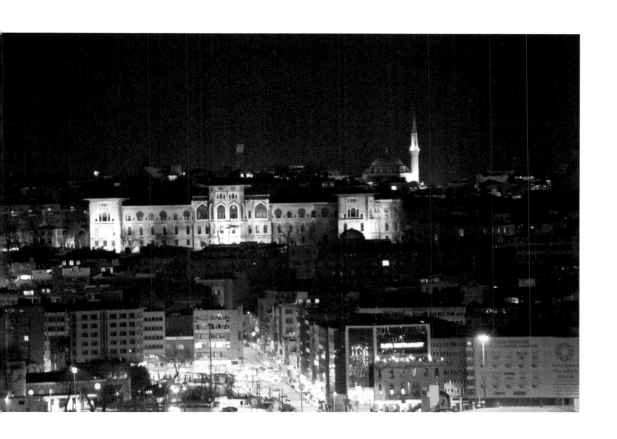

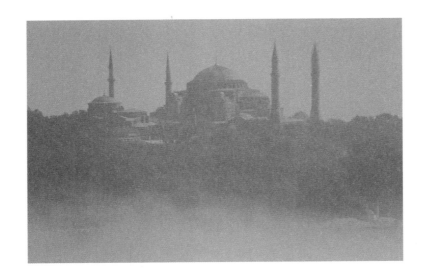

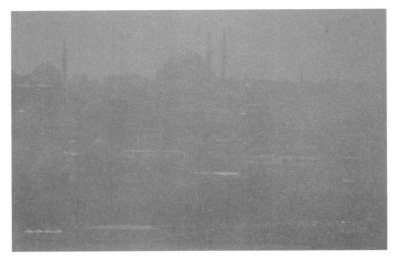

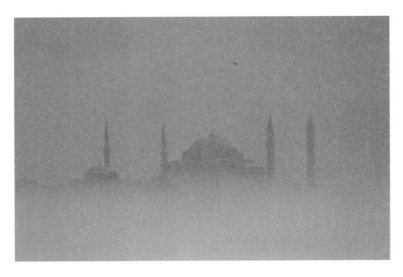

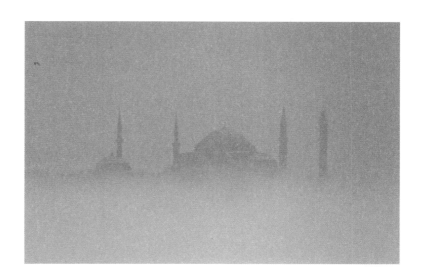

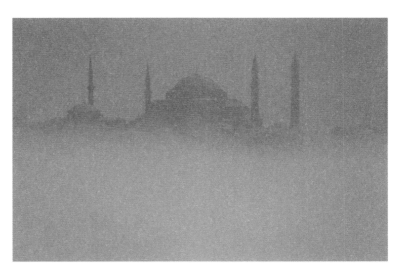

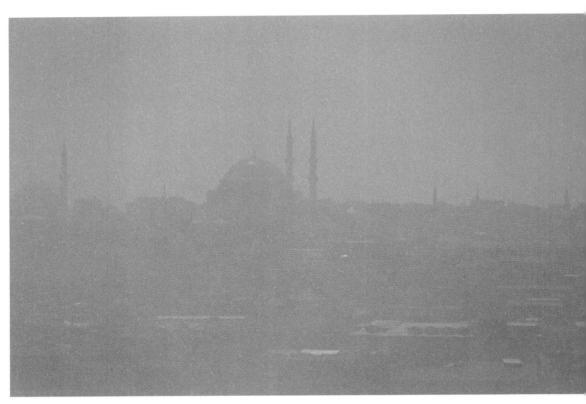

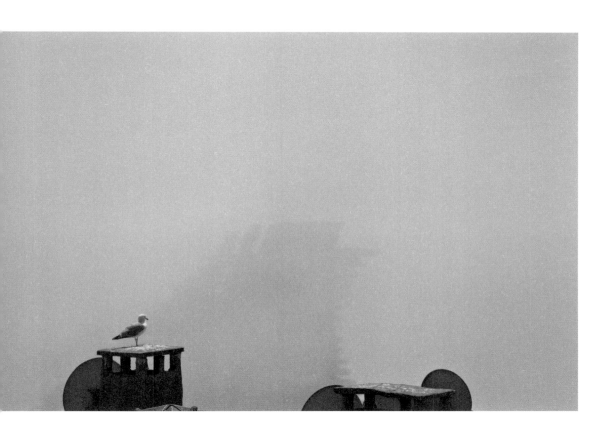

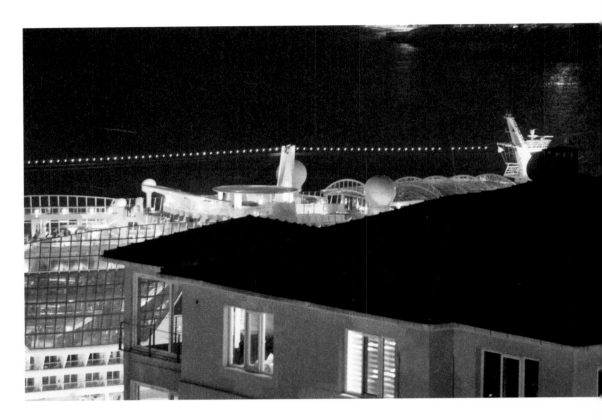

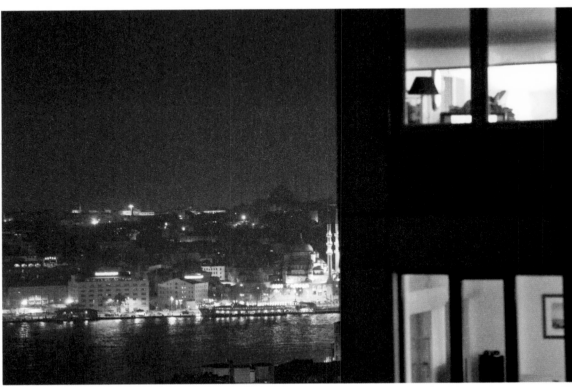

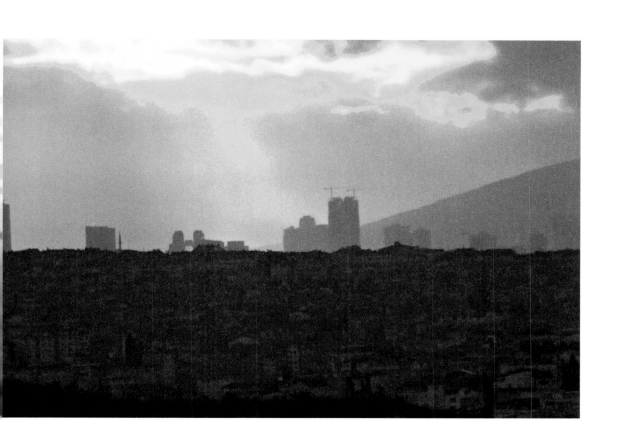

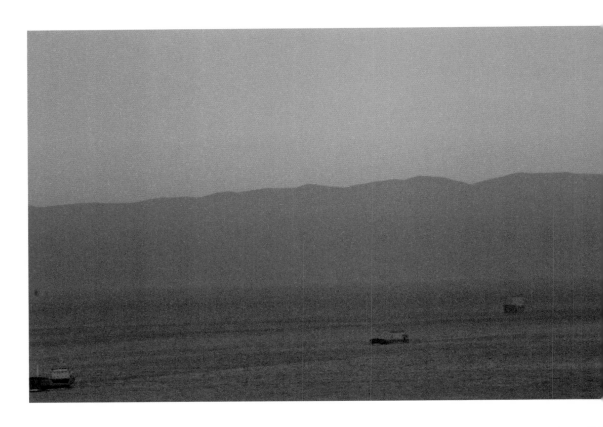

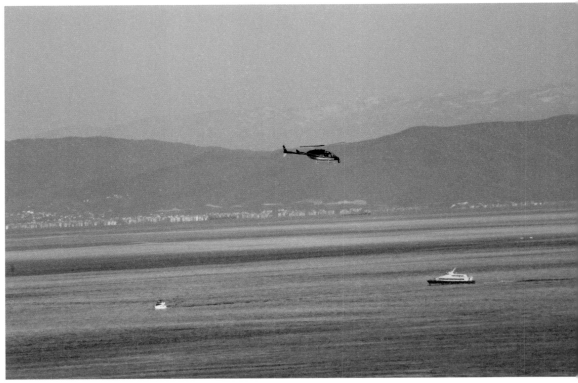

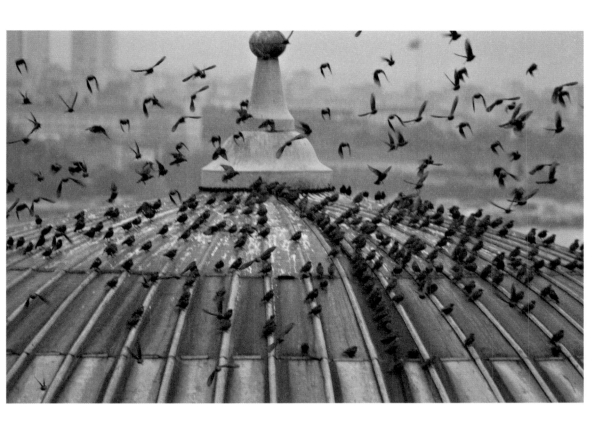

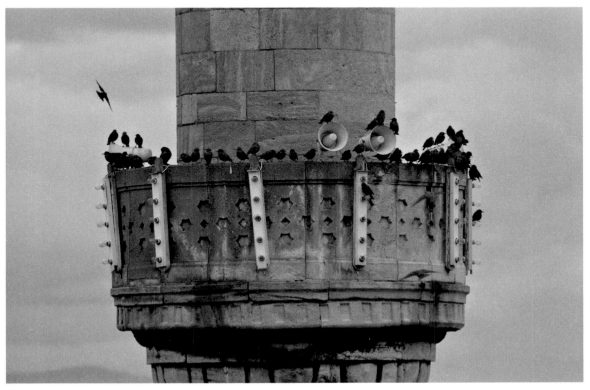

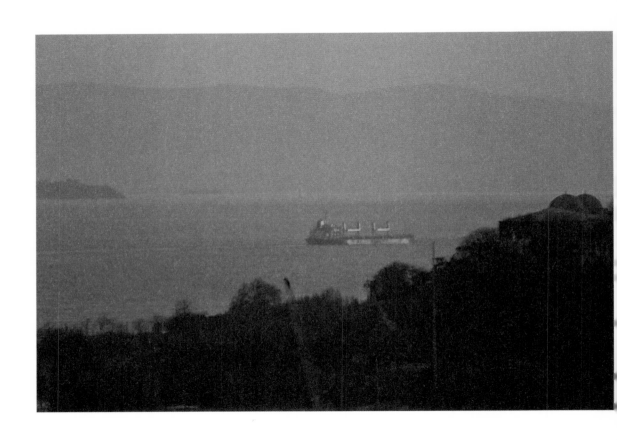

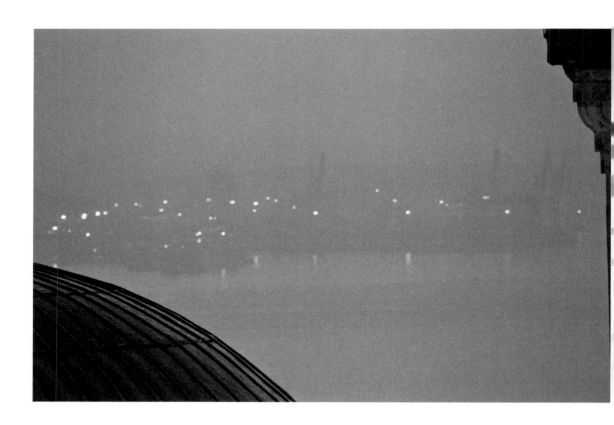

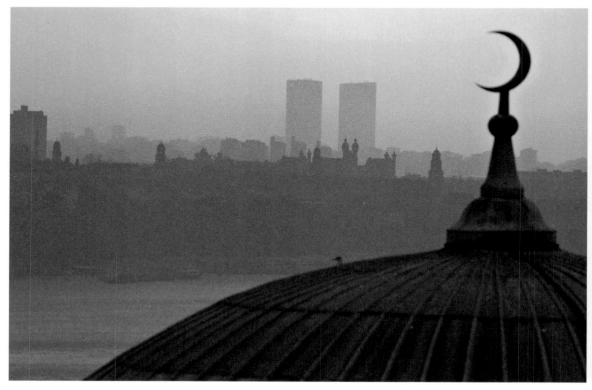

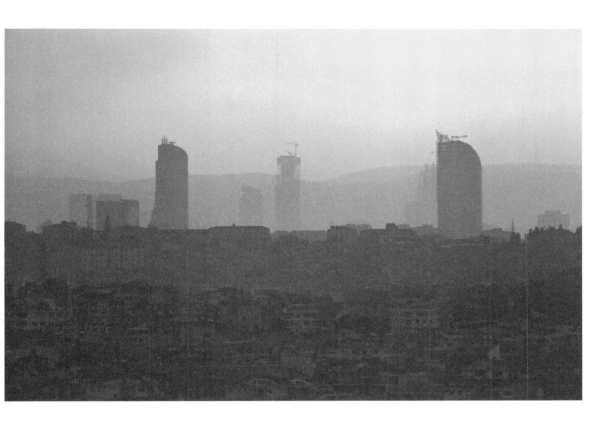

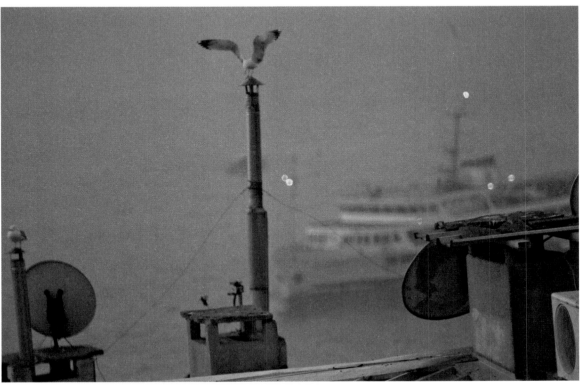

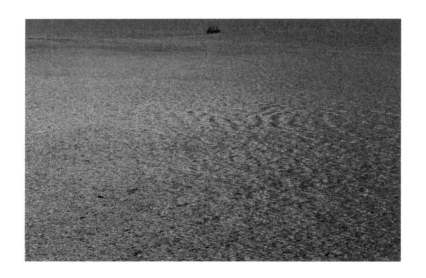

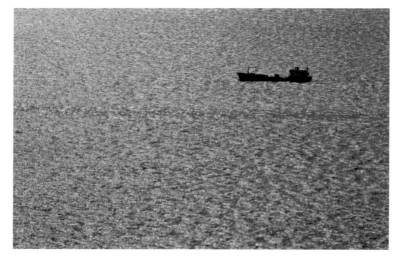

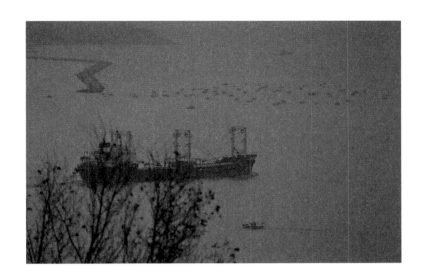

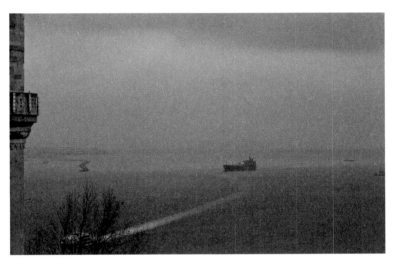

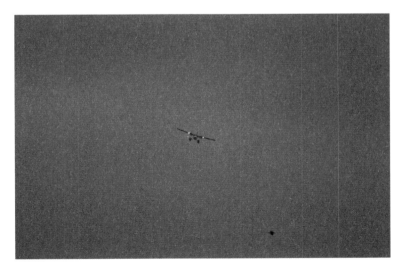

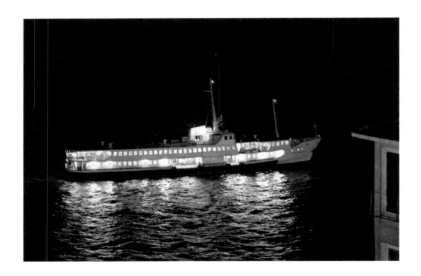

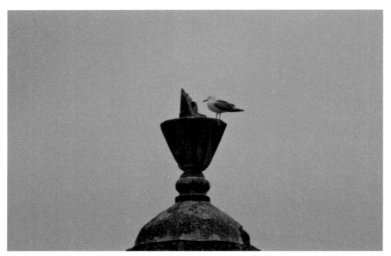

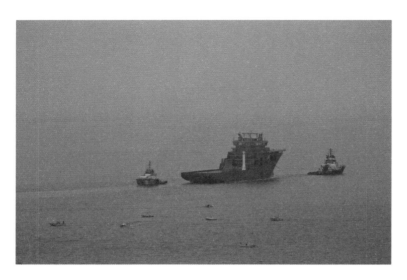

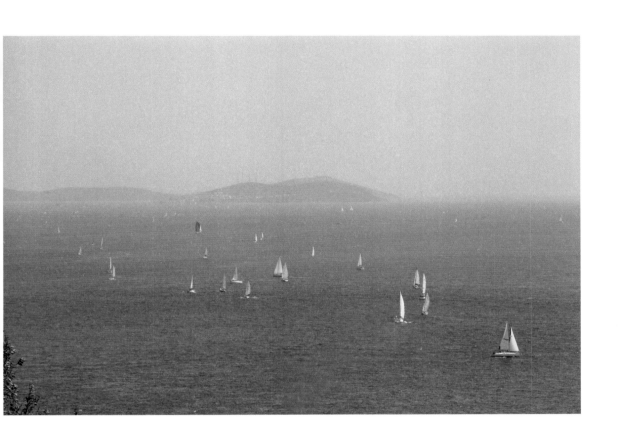

First edition published in 2018

© 2018 for the photos and text by Orhan Pamuk
© 2018 Steidl Publishers for this edition

Book design: Orhan Pamuk
© 2018 for the English translation: Ekin Oklap
Colour separations by Steidl image department

Production and printing: Steidl, Göttingen

Steidl
Düstere Str. 4 / 37073 Göttingen, Germany
Phone +49 551 49 60 60 / Fax +49 551 49 60 649
mail@steidl.de
steidl.de

ISBN 978-3-95829-399-1
Printed in Germany by Steidl